IMAGES
of America

JAMESTOWN

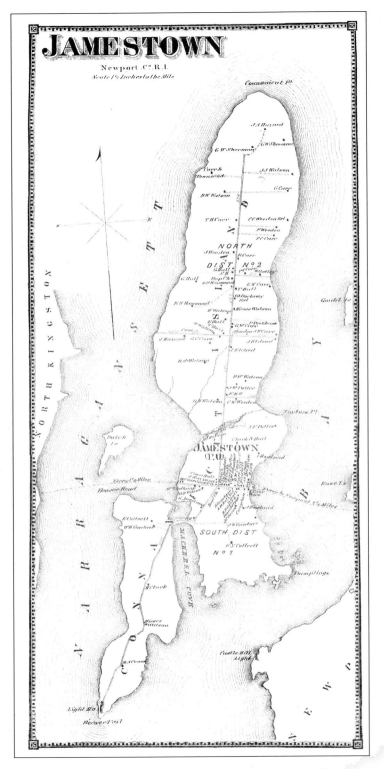

This map of Jamestown appears in the *D.G. Beers Atlas of the State of Rhode Island*, published in 1870.

IMAGES
of America

JAMESTOWN

James C. Buttrick
with the Jamestown Historical Society

ARCADIA

First published 2003
Reprinted in 2003

Published by Arcadia Publishing,
an imprint of Tempus Publishing Inc.
Portsmouth NH, Charleston SC, Chicago,
San Francisco

Printed in Great Britain

Library of Congress Catalog Card Number: 2003101686

For all general information, contact Arcadia Publishing:
Telephone 843-853-2070
Fax 843-853-0044
E-mail sales@arcadiapublishing.com
For customer service and orders:
Toll-free 1-888-313-2665

Visit us on the Internet at www.arcadiapublishing.com

On the cover: On board *Columbia,* two Whitall boys and a friend are learning to sail with Mr. Ross, the family's boatman. (Jamestown Historical Society Collection, detail.)

The seal of the town of Jamestown is centered on a sheep, reflecting the community's early history as a farm community.

CONTENTS

ACKNOWLEDGMENTS

The greatest appreciation goes to all who have generously donated photographs to the Jamestown Historical Society. Those donations have become a remarkable collection, from which this book is mostly drawn. In addition, I am most grateful to the following people, who either lent or helped me find photographs: Joe Bains, Laura Condon of the Society for the Preservation of New England Antiquities, Trudy Coxe, Alma Davenport, the Dodge family, Jane Lippincott, Sue Maden, Barbara Magruder, Walter Schroder, Anna Templeton-Cotill, William Vareika, Linda A. Warner, J.S.L. Wharton III, Henry Wood, Harrison M. Wright, and Joan Youngken of the Newport Historical Society. The research done by Sue Maden over many years has been most helpful. I particularly wish to thank Mary Miner, archivist of the Jamestown Historical Society, for her invaluable editorial help and devotion to historical accuracy. Thanks also go to Rosemary Enright, chair of the publications committee of the Jamestown Historical Society, for her editorial assistance and support of this project.

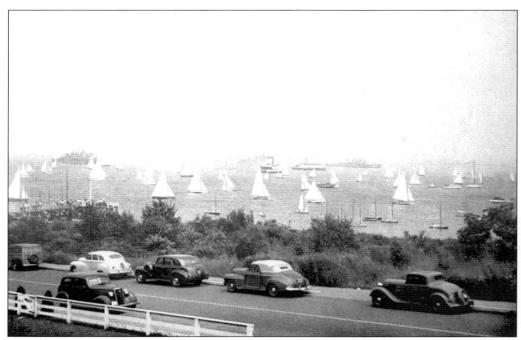

This 1940s view of the bay shows the pier of the Conanicut Yacht Club (left), two ferries, warships, and numerous racing sailboats. (Jamestown Historical Society Collection.)

INTRODUCTION

Having had the opportunity to see many of the roughly 3,000 photographs in the collection of the Jamestown Historical Society, I knew they should be more widely appreciated. Images drawn from the collection are used for exhibits and articles, but they are not seen in the number that conveys a sense of place. The hope is that a substantial portion of the collection, seen at once, will give a cohesive visual sense of Jamestown's past. The book also has a few pictures outside of the collection that are too good to exclude. The question of what constitutes the past is subjective, but if it is defined as before memory, it becomes for me the 1940s, conveniently including the 1938 hurricane, the opening of the Jamestown Bridge, and World War II. As exceptions must be made, a few post-1940s images are also included in the book.

Many of the photographs in the collection give up nothing in terms of artistic or technical quality, despite having been taken early in the development of photography. The pictures typically given to the historical society were images that were thought to have lasting interest for a variety of reasons. They may have been of the buildings that largely define the town, or subjects of local relevance, such as the ferries, or of fleeting events like the 1938 hurricane. Happily, there are also pictures of daily life, people having fun as well as doing their work. It is a cross section of these that are presented, intending to give a sense of the whole. Each of the photographs has had its own history, being passed from hand to hand, going in and out of shoeboxes. The resulting scratches or marks have not been removed, the photograph having become an artifact in it own right.

Looking at the pictures is somewhat like seeing history from the bottom up rather than the top down, and they produce their own reactions. For example, the Howland Mansion, built on the profits from subdividing the Howland farm, brings into relief the transformation of lives that development brought, and the motivation that farmers had to sell their land. The images of the diminutive steamer *Dumpling*, used as a ferry between the Dumpling dock and East Ferry, suggest how difficult it was to get from place to place before paved roads and automobiles. One thinks of ferries to get to other shores, not for transportation about the island. Another impression from the photographs came from seeing navy ships in the background of so many waterfront scenes. They were rarely the subject of the photographs because they were a constant backdrop and taken for granted. We forget that the bay once looked empty without warships.

An effort has been made to include photographs that document the ways the island has changed, particularly the buildings that have disappeared. The growth in population has meant that the town's institutions have often had to put up larger buildings and in the process demolish schools and churches that longtime Jamestown residents remember fondly. Many images show the changes in the landscape, which has evolved from open pasture largely to residential neighborhood. Houses often had views when they were built that have completely disappeared.

To see images showing how dramatically the island has been transformed raises the question of who the primary agents of change were. Conanicut Park, the first major development for summer visitors, was initiated by businessmen from Newport and Providence. It can be speculated that the ultimate failure of Conanicut Park occurred because the off-island developers were not sufficiently aware of the importance of access to the village and to the ferry.

Soon after Conanicut Park got under way, entrepreneurs from Jamestown were building more modestly and prudently at the East Ferry. The early hotels were built to serve an existing clientele, and they were expanded in stages as the business grew. By contrast, it would be Patrick H. Horgan of Newport, who arrived and built the largest hotel, the Thorndike, all at once. It appeared to be that, for better or for worse, outsiders were prepared to take the bigger risks. Local land-owning families continued selling off their property, but they typically did not make major investments in development. Several who would were St. Louis businessmen, already summer residents. They planned Shoreby Hill to include a clubhouse, a pier, bathhouses, sidewalks, and a sanitation system. No doubt they were motivated in part by the fact that they planned to live in Shoreby Hill and wanted to attract like-minded neighbors. Nonetheless, Shoreby Hill was a more comprehensive project than usual and fit the pattern of larger-scale development by outsiders, doubtless aided by their access to financing.

It is remarkable to consider what a short time it took to transform Jamestown from a predominantly agricultural community of over two centuries' duration to a fashionable summer resort. That transition began in 1872 with Conanicut Park and could be considered complete by 1895, when Shoreby Hill was laid out. In those 23 years, five major hotels were constructed, as well as many smaller accommodations. The farms in the vicinity of the village were subdivided. The Dumplings and Walcott Avenue acquired many houses in the popular Shingle style, and a golf club and yacht club had been established. Even Forts Wetherill and Getty were planned, although a few years would pass before construction began. Fort Wetherill would require the destruction of several substantial summer houses built only two decades previously. Perhaps even more remarkable, given the rapidity of these changes, is that Jamestown has preserved over the last century the village character and active waterfront that made the island so appealing in the first place.

One

THE AGRARIAN PAST

English colonists first came to Jamestown (or Conanicut Island) in 1638, when the Narragansett Indians gave them permission for grazing. In 1657, the Native Americans sold the island to approximately 100 farmers and investors, known as proprietors. The proprietors divided 4,800 of the island's 6,000 acres into lots that were proportionate to each proprietor's investment. The remainder of the land was reserved for a township and various community purposes. Among the proprietors was Benedict Arnold (great-great-grandfather of the traitor), who, with 1,411 acres, was the largest landowner. Arnold would later be chosen governor of the colony, as would two other proprietors, Caleb Carr (with 120 acres) and William Coddington (with 240 acres). In general, the proprietors did not actually live on Conanicut Island, although many of their descendants have.

Early agriculture comprised mainly the raising of sheep and dairy cattle, with beef cattle becoming more popular as beef became a regular part of the colonists' diet. Corn was the primary crop, and it was ground into meal at a Jamestown windmill as early as 1730. The third windmill on the island was built in 1787 on North Main Road and is maintained in working order by the Jamestown Historical Society. Adjacent to the windmill are the miller's cottage and the Friends Meeting House, also built in 1787. Through the 18th century, agriculture flourished in Jamestown as a result of fertile soil, access to water, a climate tempered by the sea, and tolerance of slavery. Prosperous farmers built substantial farmhouses with symmetrical facades, center chimneys, and massive post-and-beam framing. Among the survivors is the Thomas Carr Watson farmhouse (1796), which is maintained as part of a 258-acre working farm by the Society for the Preservation of New England Antiquities. Another large 18th-century farmhouse that still exists in its original landscape is on Fox Hill Farm. The farm is part of the property purchased by Governor Arnold, and the gambrel-roofed farmhouse may include a portion of the original house. The late-18th-century Dumplin Farm would later play an important role in Jamestown's development as a summer resort when its scenic shorefront property in the Dumplings was sold for summer homes by the Ocean Highlands Company.

The island's early prosperity ended with the Revolutionary War. In December 1775, the British landed and burned many buildings along Narragansett Avenue. Across the bay, Newport was occupied by the British from December 1776 to October 1779, and for nearly all of this period, Jamestown was also occupied. Rhode Island's economic expansion in the 19th century did not include Jamestown. It was an industrial expansion dependent on power from waterways. Without a source of waterpower, Jamestown languished and its depressed economy helped explain the rapidity of its development as a resort.

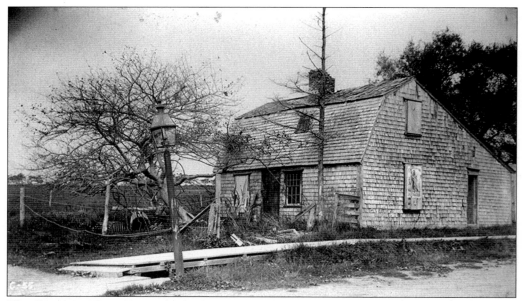

The Benjamin Carr House, built c. 1809, stood on Conanicus Avenue to the north of an 18th-century ferry house that was subsequently replaced in 1889 by the Bay View Hotel and, more recently, by the Bay View Condominiums. About 1910, it served as the waiting room for the Narragansett Transportation Company, a ferry line in competition with the Jamestown and Newport Ferry Company. (Jamestown Historical Society Collection.)

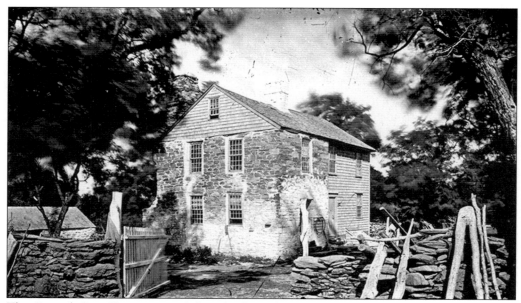

The Samuel Carr House, one of the island's earliest houses, was built for Richard Smith of Cocumscussoc. Smith sold it to John Hull in 1687, and the house remained in the Hull family until Samuel Carr bought it in 1770. A rare stone ender, the house burned down c. 1956. It was located on North Main Road, just south of West Reach Drive. (Jamestown Historical Society Collection.)

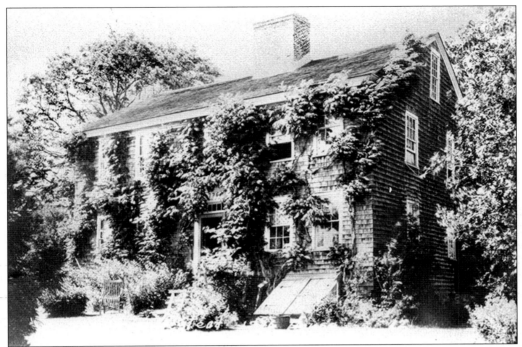

The Carr Homestead was built in the late 18th century by Nicholas Carr. Typical features of the period are the center entry and a large central chimney, which services six fireplaces. Actively farmed until the 1950s, the farm remains in the Carr family. (Jamestown Historical Society Collection.)

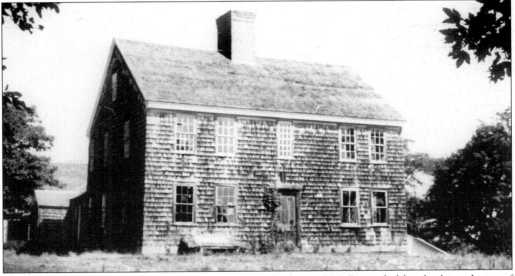

The house on the Thomas Carr Watson farm was built in 1796. Remarkably, the boundaries of the farm have hardly changed since it was laid out in 1657. Sited on one of the highest points on the island, the intact landscape permits excellent views to the bay. The property can be visited as an example of a traditional New England working farm. (Courtesy of the Society for the Preservation of New England Antiquities.)

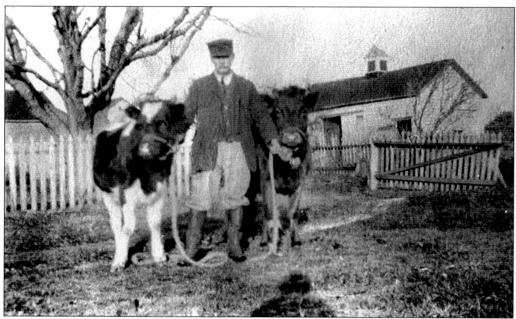

The Brayman farm was on North Main Road at Rosemary Lane. In this early-1900s view, John Brayman and his cows appear content with each other. The cupola seen on the barn in this photograph is a somewhat unusual feature on Jamestown barns. (Jamestown Historical Society Collection.)

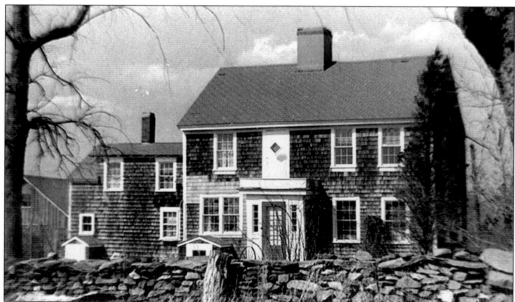

Located to the south of Route 138, the Carr-Hazard House was built c. 1760 and was occupied by members of the Carr family or Hazard family until 1960. Originally a farm of 100 acres, it was combined with other property of Thomas Hazard on the north side of Route 138 in the early 19th century. Most of the farm was sold in the 1940s to become Jamestown Shores. (Jamestown Historical Society Collection.)

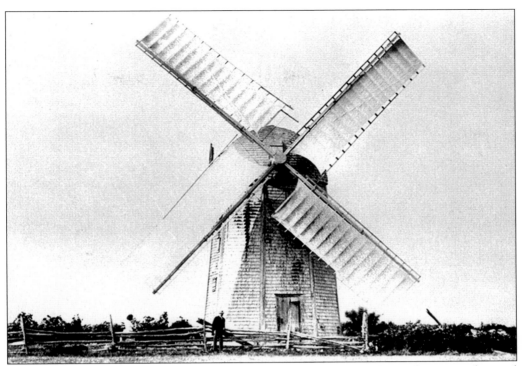

This, the third windmill in Jamestown, was built in 1787 and ground corn for jonnycake meal and cattle feed until 1896. The Jamestown Historical Society maintains the mill and opens it to visitors on summer weekends. (Jamestown Historical Society Collection.)

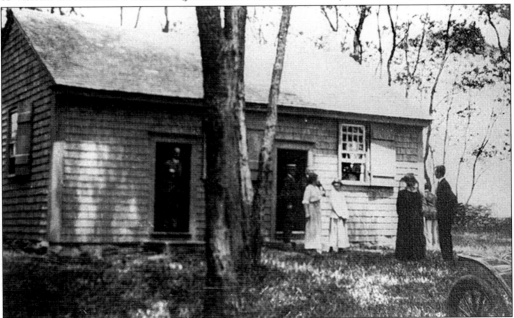

Built in 1787, the Friends Meeting House continues in use throughout most of the year. (Jamestown Historical Society Collection.)

The late-18th-century Cottrell farm was purchased in 1844 by John Cottrell, but his son Frederick preferred land development. Frederick was a partner in the Ocean Highlands Company, which subdivided the adjoining Dumplin Farm in 1875 for summer residences. In 1887, Frederick's heirs platted lots for summer homes along the east and west waterfronts, leaving a working farm in the center of the property. (Jamestown Historical Society Collection.)

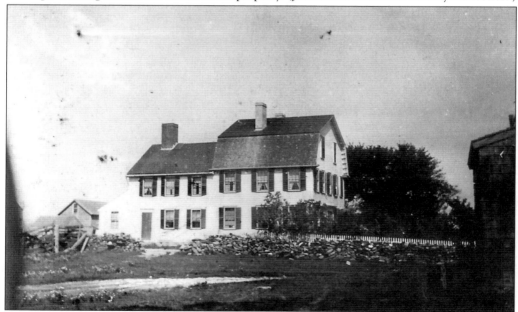

Gov. Benedict Arnold, great-great-grandfather of the traitor, left 500 acres on the northern part of Beavertail to his son Josiah in 1679. Josiah built a house on the property, which may be the western end of the present farmhouse. The eastern, gambrel-roofed section is thought to have been built by Josiah's son Benedict in the early 18th century. (Jamestown Historical Society Collection.)

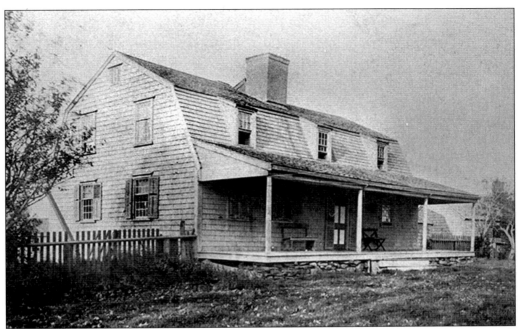

Prospect Hill Farmhouse was built in the late 18th century. The farm was owned in the 19th century by Henry Audley Clarke, who built a summer house that later became the clubhouse of the Beavertail Country Club created on the farm by his son Audley. (Jamestown Historical Society Collection.)

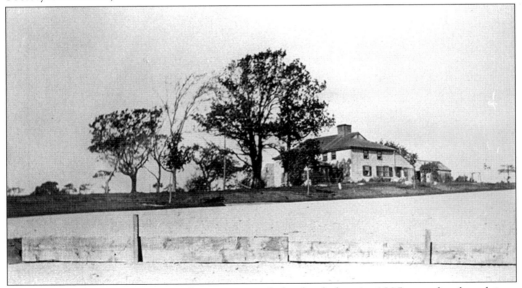

The early-18th-century Greene farm comprised the land that in 1895 was developed into Shoreby Hill. David Greene bought the property in 1712 and is assumed to have built his house soon after. The Greenes farmed the land until 1840, when David Greene's grandson Joseph left the farm to the Society of Friends. The photograph appears to have been taken during early road construction for Shoreby Hill. (Jamestown Historical Society Collection, original at Newport Historical Society.)

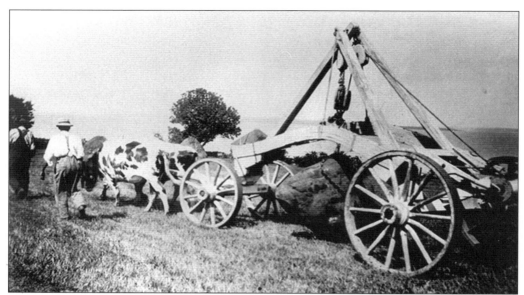

The unusual piece of farm equipment pictured is a four-wheeled galamander. It is being used by Oliver D. Sprague to remove a boulder from a field at Cajacet. (Jamestown Historical Society Collection.)

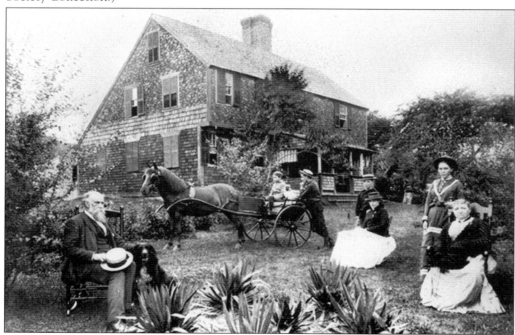

The house shown in this photograph was built by Capt. Thomas Paine c. 1691. A retired privateer, sometime pirate, and friend of Captain Kidd, Paine gained the respect of the community when he successfully defended Newport against a fleet of five French pirate ships. Seth M. Vose, a Providence and Boston art dealer, bought the house in 1882 and named it Cajacet. Over the years, the size and appearance of the house have changed, but traces of the original building can still be found. (Jamestown Historical Society Collection.)

Two

Crossing the Bay

For over 300 years, ferries were the main link between Jamestown and the mainland, a network that may have been the first ferry system in the United States. For over 200 years, those ferries were sailboats, generally sloops measuring between 35 and 40 feet long. They carried livestock and freight as well as passengers, and their schedules were entirely dependent on the weather. A brief attempt at a horse-powered ferry in 1829 ended in failure.

While this level of service may have been adequate for farmers and merchants transporting produce and supplies, it was completely inadequate to entice tourists. By 1872, the passenger fare is believed to have been $1 per trip, and demand for better and cheaper service was high. The town petitioned the General Assembly for permission to establish a steam ferry service, and the Jamestown and Newport Ferry Company was formed. It had an unusual ownership structure, with a 60 percent interest held by the town and a 40 percent interest held by investors. By May 1873, the *Jamestown*, a 79-foot side-wheeler, was making five round trips each day to Newport, roughly twice the frequency of the sailing ferries. At the time, three land-development plans for the village area were under way, and the development of the Ocean Highlands and the Bay View plats was to begin shortly. The newly reliable ferry service was critical for Jamestown's success as a summer resort.

The saga of the ferries, once steam power was established, became one of gradually increasing size, capacity, and comfort. The 125-foot *Conanicut* replaced the 79-foot *Jamestown* in 1886 and provided a cabin on the upper deck for passengers. Over the years, the steam ferries that were displaced on the Jamestown–Newport run were often relegated to service on the West Bay to Saunderstown. This happened with the *Jamestown* in 1888, when that run was inaugurated. For a time, there was competition among ferry companies, as in 1906, when the Narragansett Transportation Company obtained a charter for service from Saunderstown to Newport. The ferries themselves often had histories of their own, serving in other locations before coming to Narragansett Bay. For example, the *Hammonton*, built in 1906, was brought to Jamestown in 1930 and remained in service until 1958, its appearance changing significantly over time.

Eventually, the volume of automobile traffic and the desire for convenience overwhelmed the capacity of the ferries. A bridge across the West Passage had been proposed in the 1920s, but it gained new impetus during the Great Depression, when tourist traffic was declining and losses to the town from supporting the ferry system mounted. The availability of financing from the Public Works Administration for 45 percent of the cost was a critical element in making the bridge a reality. Adding to the momentum that was building for the project was the devastation brought by the 1938 hurricane, especially the damage to the ferries and their landings. In July 1940, the Jamestown Bridge opened for traffic, having been built in 18 months and under budget at a cost of $3,002,218.02.

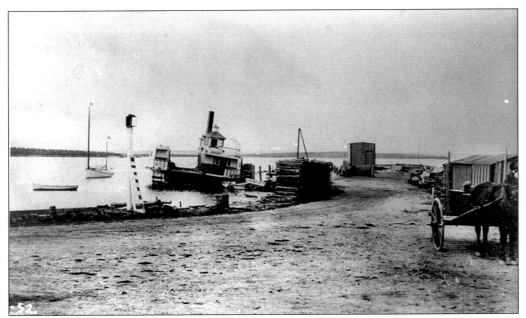

The *Jamestown* listed to one side when unloaded, as in this picture, since the power plant was on one side, and the other was reserved for vehicles and freight. The 79-foot ferry was propelled by paddlewheels driven by a wood-fired boiler. Fore and aft of the paddlewheel housing on the vehicle side were narrow cabins for passengers. The *Jamestown* crossed the East Bay from 1873 to 1886 and subsequently inaugurated steam service on the West Bay. (Jamestown Historical Society Collection.)

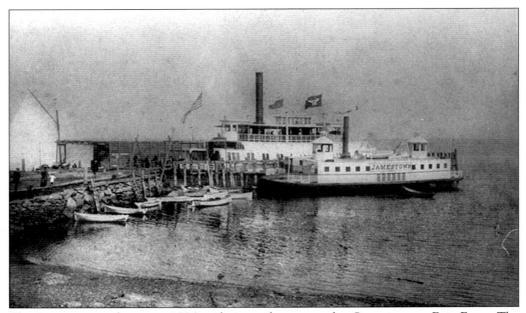

The *Jamestown* is shown in 1886 with its replacement, the *Conanicut*, at East Ferry. The *Conanicut* was more than half again the length of the *Jamestown*, and with dual carriageways, it added significant capacity to the run. (Jamestown Historical Society Collection.)

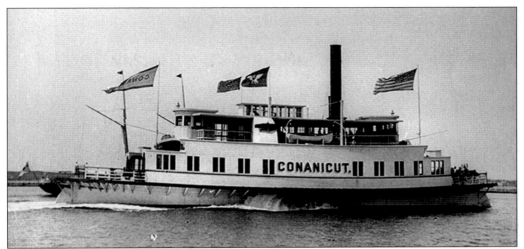

Passengers aboard the *Conanicut* could be accommodated on the upper deck, and they could watch through a glass enclosure the walking beam powering the paddlewheels. The *Conanicut* served until 1927, when it was chartered by the Short Line Bus Company for service between Portsmouth and Bristol until the Mount Hope Bridge was built. (Jamestown Historical Society Collection.)

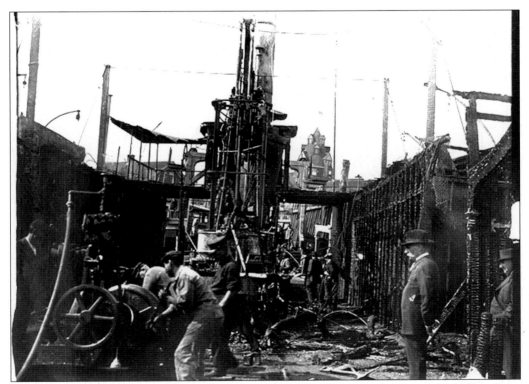

On September 20, 1914, the *Conanicut* was gutted by fire. It was sunk to save the hull and the engine, and the superstructure was rebuilt. In this photograph taken during post-fire repairs, a bilge pump is being installed. The tower of the Bay View Hotel is seen in the background. (Jamestown Historical Society Collection.)

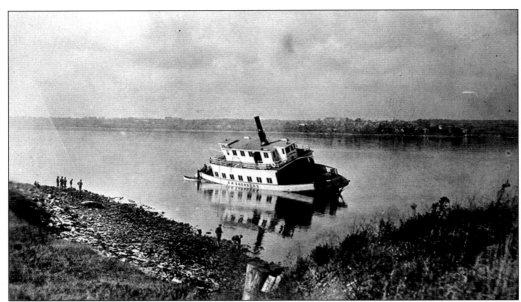

The *J.A. Saunders* is shown aground off Dutch Island in 1917. The ferry was built on the beach at Saunderstown by the Narragansett Transportation Company, which was in competition with the Jamestown and Newport Ferry Company. Each firm had its own landings at the East and West Ferries and at Newport. In 1911, the Narragansett Transportation Company was bought out by the Jamestown and Newport Ferry Company. (Jamestown Historical Society Collection.)

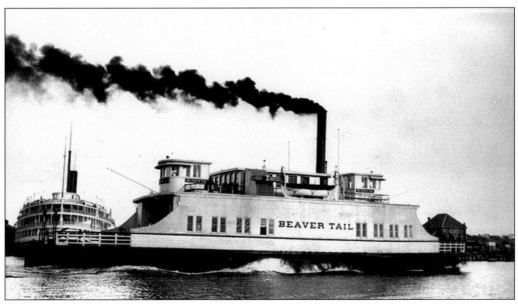

The *Beaver Tail*, built in 1896, was 110 feet long and had side paddlewheels. Here, the *Beaver Tail* is seen passing the New England Steamship Pier in Newport, where connections to Fall River or New York could be made. In the summer months, the ferry ran a special trip that left at 8:20 p.m. and went directly to the Steamship Pier to connect with the night boat to New York, which left at 10:00 p.m. (Jamestown Historical Society Collection.)

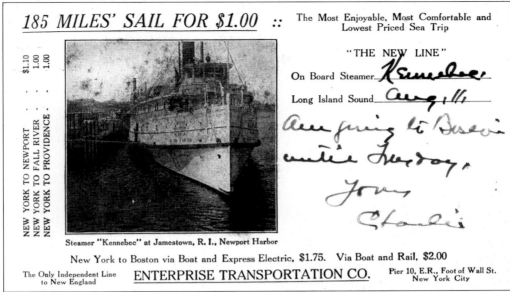

Steamships connecting to New York stopped at Jamestown in 1906–1907. The Enterprise Transportation Company, known as the New Line or the Opposition Line because it challenged the Fall River Line, had a wharf next to the ferry landing. Passenger fare to New York was $1 on the New Line and $3 on the Fall River Line. The service was popular, but a financial panic in 1907 put the company into receivership. (Joe Bains Collection.)

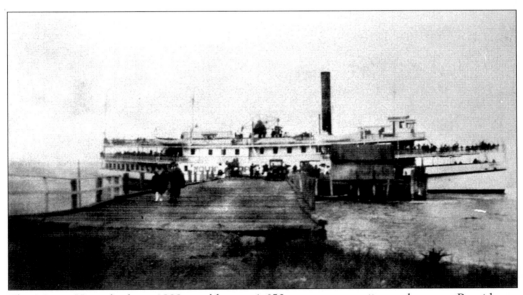

The *Mount Hope*, built in 1888, could carry 1,650 passengers on its run between Providence and Newport, with stops at Conanicut Park and Prudence Island. Conanicut Park, at the North End, was dependent on steamers like the *Mount Hope* because of its distance from East Ferry. This 1931 view is near the end of the life of this steamer and well past the heyday of Conanicut Park. (Jamestown Historical Society Collection.)

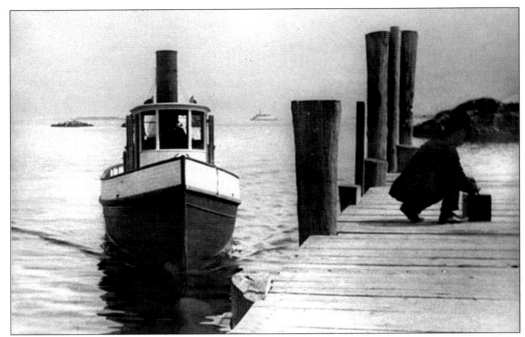

The steamer *Dumpling* carried 30 passengers on its run between the East Ferry and the Dumpling dock. Service began in 1888, just as large summer houses were being built in the area, and continued for several seasons. The alternative route to town, a carriage along Walcott Avenue, was longer and less comfortable. (Jamestown Historical Society Collection.)

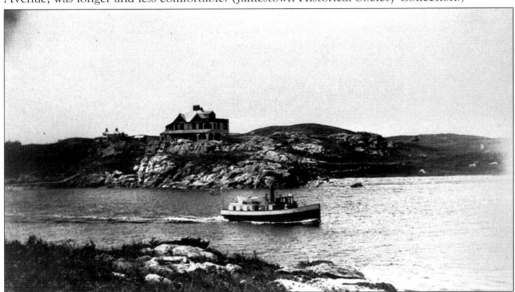

The steamer *Dumpling* is en route to East Ferry. In the background is the Barnacle, built in 1886 as the summer residence of Adm. Thomas O. Selfridge Jr. It is one of several houses designed by Charles Bevins to perch on the rock outcroppings of the area. The lack of vegetation made these rock formations far more prominent than they are currently. (Jamestown Historical Society Collection.)

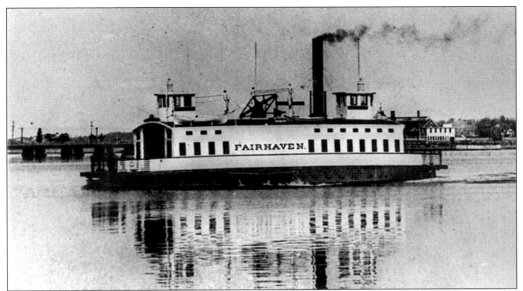

The *Fairhaven*, built in 1896, is shown in service between New Bedford and Fairhaven *c.* 1910 with the walking beam operating the paddlewheels clearly visible. When the ferry subsequently operated at New London, the name was changed to the *Mohican*. In 1929, it began service in the West Passage. (Jamestown Historical Society Collection.)

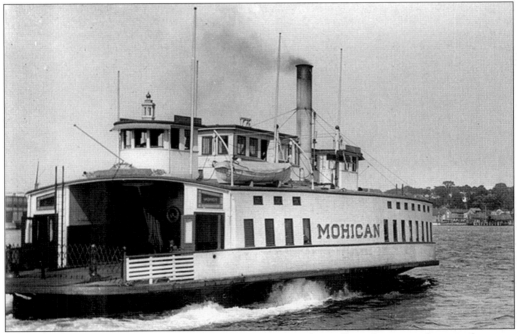

By the time the *Mohican* was operating at Jamestown, the walking beam evident in the prior photograph had been completely enclosed. The ship's operation lasted only months, and in the depths of the Great Depression, the Jamestown and Newport Ferry Company permitted the unemployed to break up the superstructure of the idle ferry for firewood. (Jamestown Historical Society Collection.)

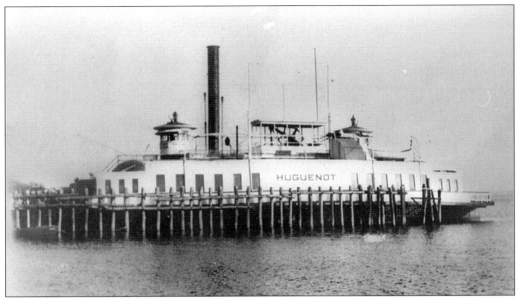

The *Huguenot* arrived in Jamestown in 1923 and became the *Jamestown II*. It had begun life, however, in 1884 in Newburgh, New York, as the *Fishkill-on-Hudson* and became the *Huguenot* on Long Island Sound. As with other early boats, the *Huguenot* was a side-wheeler and had exposed machinery on the boat deck and no accommodation for passengers. (Jamestown Historical Society Collection.)

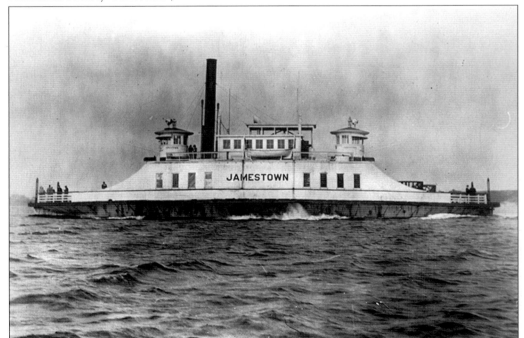

The *Huguenot* became much sleeker as the second *Jamestown*, with its reworked sides given graceful lines. It also became more comfortable for passengers, with a cabin added on the upper deck. It was retired in 1938. (Jamestown Historical Society Collection.)

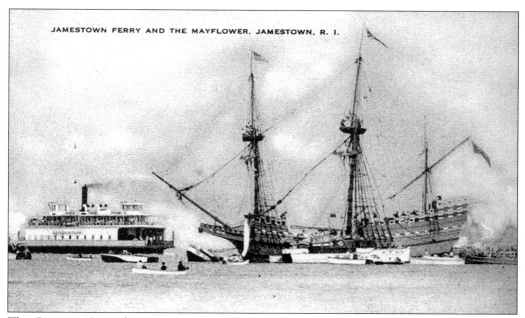

JAMESTOWN FERRY AND THE MAYFLOWER, JAMESTOWN, R. I.

The *Governor Carr*, shown with a much smaller *Mayflower* replica in the foreground, was the last ferry to be built expressly for Jamestown. In service from 1927 to 1958, the *Governor Carr* was popular with passengers because of its accommodations, which included a gentlemen's smoking room and a ladies' lounge. (Jamestown Historical Society Collection.)

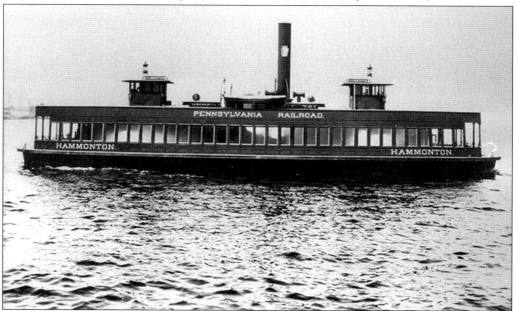

The *Hammonton* began as a passenger ferry in 1906 for the Philadelphia and Camden Ferry Company, a subsidiary of the Pennsylvania Railroad. There was a spacious passenger cabin, and the upper deck provided protection to the ends of the boat. In 1930, the *Hammonton* was bought for service on the West Bay. (Jamestown Historical Society Collection, original at Steamship Historical Society of America.)

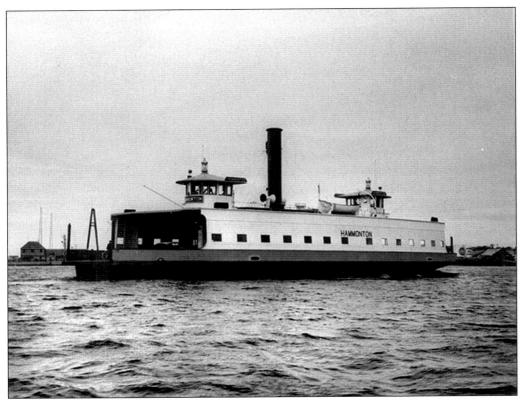

The *Hammonton* looked quite different on Narragansett Bay with its passenger compartment having been replaced by four vehicle lanes. Although there were plans to add passenger cabins topside, passengers never got more than benches on the lower deck. A heated bus was chained to the deck for passengers in winter. The upper deck was cut back for an appearance less like a railcar. In 1949, federal regulations required the ports to become much smaller. (Jamestown Historical Society Collection.)

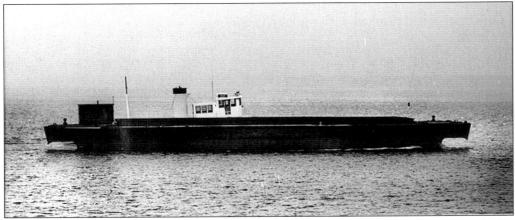

In 1958, the *Hammonton* was sold for scrap, but it became a coal barge before it was finally broken up. (Jamestown Historical Society Collection.)

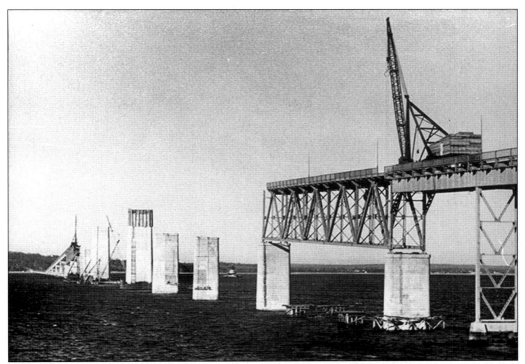

Work on the Jamestown Bridge began in January 1939 and was completed in only 18 months. Two derricks constructed the superstructure, each working toward the center. They lifted steel girders from barges below and set them in place on piers in front of them. Tracks were laid on the new structure, and the derricks could then move ahead to the next section. (Jamestown Historical Society Collection.)

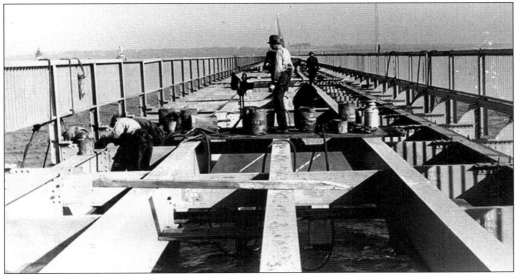

Workers near the Bonnet Shores end of the bridge are riveting the structure of the roadway. Teams of four men heated, tossed, caught, and inserted each rivet, a process of construction now technologically outmoded. (Jamestown Historical Society Collection.)

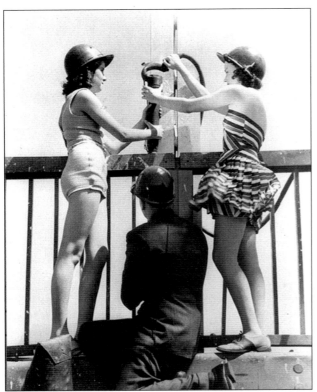

This picture of young women helping a riveter was part of a publicity campaign to raise the interest of motorists before the bridge opened. The publicist claimed that 500 newspapers used his material during the six months of the campaign. (Jamestown Historical Society Collection.)

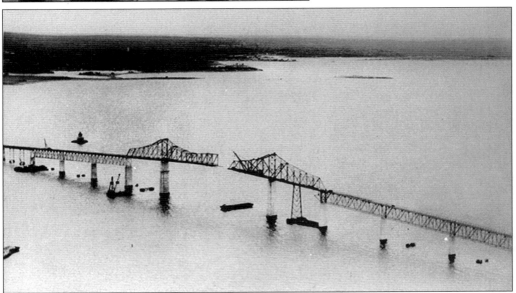

On June 12, 1940, the two sides of the bridge were connected, and 45 days later, it was open for traffic. The Jamestown Bridge was designed by the New York engineering firm of Parsons, Klapp, Brinckerhoff, and Douglas. A company history indicates that the design was based on the Cooper River Bridge, which Waddell and Hardesty had designed for Charleston, South Carolina, in the 1920s. (Jamestown Historical Society Collection.)

Three

A SUMMER RESORT

Several factors set Jamestown on the path to becoming a resort: post–Civil War prosperity that encouraged entrepreneurs to build hotels and develop land; the desire of those who could afford it to escape increasingly noxious cities; and, for Jamestown in particular, the reliable transportation service of the new steam ferry. The beginning of the resort era can be marked by the development in 1872 of Conanicut Park at the north end of the island. In many ways, it is the most interesting of the various developments because it was the most daring. At its inception, Jamestown had no reputation as a vacation destination, so the promoters had to sell the place as well as their project. The location of Conanicut Park was as far from the facilities of the village as one could get, and the development was unable to make use of the one great advance that was to promote tourism—the steam ferry. The timing of Conanicut Park was not fortuitous, since a financial panic occurred during the first year of operation. Nonetheless, a start was made.

Although Conanicut Park was not successful in the long run, it prompted farmers and others to think about development. The growth occurred incrementally, gradually expanding from the immediate vicinity of the East Ferry. The first Bay View Hotel on Narragansett Avenue (later enlarged by a four-story addition with a taller corner tower) was convenient to the village and the ferry. The later major hotels, the Gardner House, the Thorndike Hotel, and Bay Voyage Hotel, were all within walking distance of the ferry to Newport.

The first land-development scheme was Ferry Meadow, just south of the village, between Union and Brook Streets, with others to follow. A much larger scheme was undertaken on one of the three adjoining farms south of Hamilton Avenue that belonged to the Cottrell family. In 1874, the Ocean Highlands Company purchased the Cottrells' 239-acre Dumplin Farm for subdivision. As at Conanicut Park, transportation was an issue at Ocean Highlands, and perhaps an overriding one, since no houses were built until 1881. Even then, the first builder, the marine artist William Trost Richards, was given his property by the Ocean Highlands Company to give impetus to the development. Richards was from Philadelphia and doubtless contributed to the subsequent popularity of the area among Philadelphia Quaker families. In contrast to Conanicut Park, which was laid out in one-eighth-acre lots that were priced at $150, the Dumplings properties could be upwards of 30 acres.

In the late 1890s, Shoreby Hill was developed by a group of summer residents from St. Louis. They laid out private streets in a naturalistic scheme that resembled private residential enclaves in St. Louis. As with some of the other developments, Shoreby Hill had its own pier and bathhouses. It also had the Shoreby Hill Club, where residents could take their meals, reducing the need for servants. Later, the Shoreby Hill Club was moved to Conanicus Avenue, where it became a social club known as the Casino. Other clubs evolved to serve the needs of summer residents: a yacht club, a gentlemen's club, and, over time, three different golf clubs. Lest it be thought that Jamestown had become exclusively a resort for the affluent, it should be remembered that the Seaside Home in Conanicut Park had been established to provide a respite for women who worked in factories. For those who had more specific needs, there was Dr. Bates's Electropathic Sanitarium. Jamestown could accommodate nearly anyone.

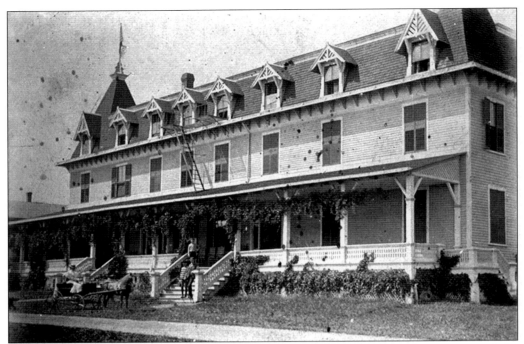

The remoteness of Conanicut Park made the steamboat landing and the creation of the Conanicut Park Hotel in 1873 critical to getting the development under way. The hotel itself was a conservative structure, with short towers flanking a mansard roof for a bit of style. Accommodation could be had for the season at $2 per day or, for transients, at a rate of $3 per day. (Jamestown Historical Society Collection.)

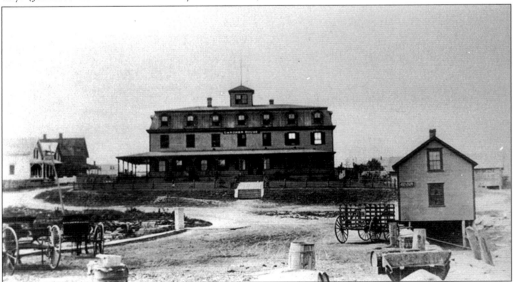

The original Gardner House building was constructed in 1883, with various extensions and additions to follow over the years. The rudimentary development of the East Ferry area can be seen a little over a decade after the regular service of the steam ferry began in 1873. (Jamestown Historical Society Collection.)

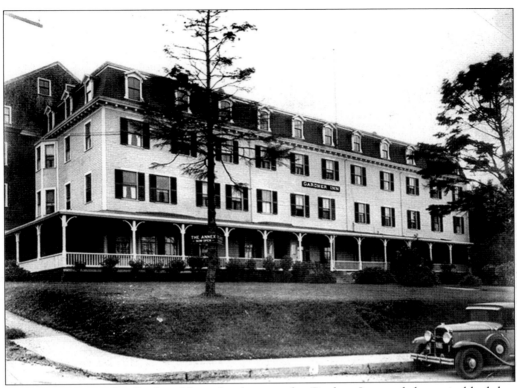

In this 1932 view, the Gardner House has become the Gardner Inn, and the main block has been expanded from 7 window bays to 11. The roof has been raised and a new second story inserted. A major addition has been made to the rear along Union Street. (Jamestown Historical Society Collection.)

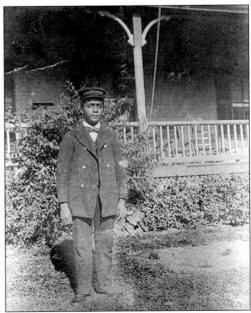

Jim was the elevator boy at the Gardner House in 1905. (Jamestown Historical Society Collection.)

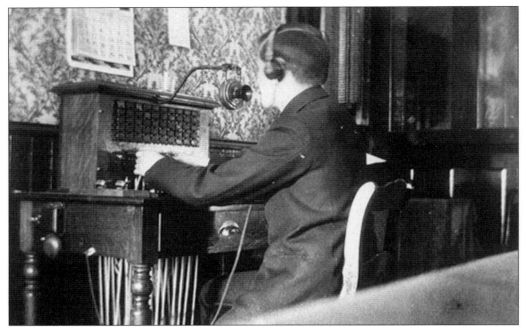

The first telephone service in Jamestown was to the Thorndike Hotel in 1894, and shortly thereafter, a switchboard for local service was established at the Gardner Hotel, pictured above. This switchboard initially operated only in summer, necessitating all off-season local calls being routed through Newport at toll rates. After considerable dissatisfaction, a year-round switchboard was established in 1914. (Jamestown Historical Society Collection.)

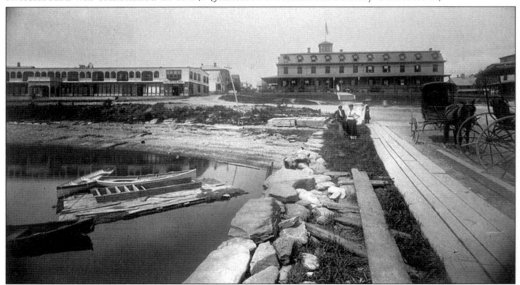

In April 1889, Patrick Horgan, a real estate investor from Newport, bought two lots on Conanicus Avenue at auction. By August, he had constructed the first two floors of the Horgan Hotel (left), later called the Thorndike Hotel, roofed them over, and was renting out rooms. By the following summer, the hotel was complete. The Gardner House is on the right, having been expanded in length but not yet in height. (Jamestown Historical Society Collection.)

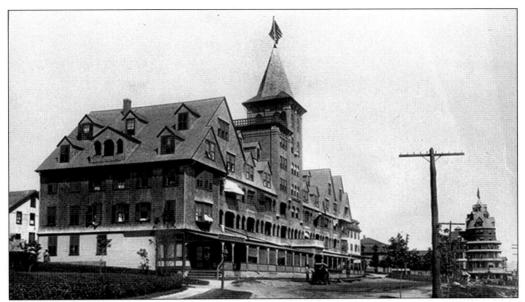

The completed Thorndike Hotel, designed by Charles Bevins, fit well with the Shingle-style houses being built on the island at the time. The hotel kept up with the times, acquiring a water-powered elevator in 1891 and a 25-horsepower generating plant in 1899. The latter was designed to light the hotel's public rooms and shops as well as the "Three Sisters" cottages next door. (Jamestown Historical Society Collection.)

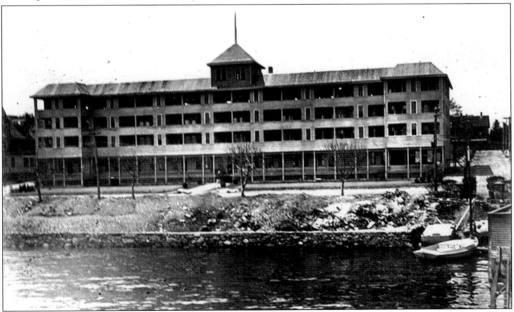

The original Thorndike Hotel, destroyed by fire in 1912, was replaced by this structure the next year. It was known as the Tin Palace for its pressed-tin ceilings and walls, a fire-protection measure. Perhaps of more interest to guests were the private baths. During the Great Depression, however, there was little demand for hotel rooms, and the new Thorndike was pulled down in 1938 a week before the hurricane struck. (Jamestown Historical Society Collection.)

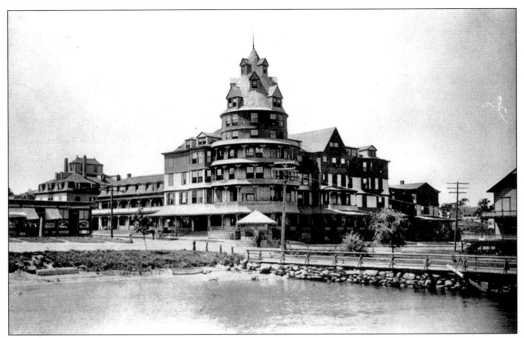

The Bay View Hotel was expanded in 1889 at the height of the building boom. The builder was Adolphus Knowles, whose father had built the original Bay View Hotel (two-story wing to the left) in 1872. This hotel made a major architectural statement with its dormered tower and four levels of encircling porches. Serving 97 rooms on five floors were 15 water closets and one bathtub. (Jamestown Historical Society Collection.)

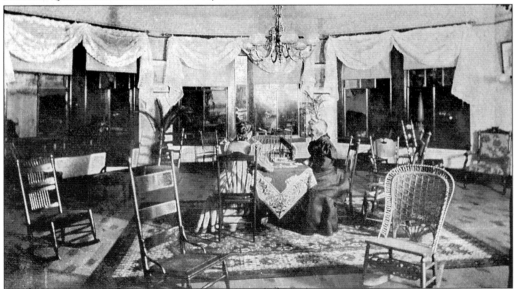

The lobby of the Bay View Hotel showed that decor appropriate to a summer hotel included simple furniture, casually arranged. Of the 14 chairs evident in the picture, there are only two pairs, suggesting a certain informality. The lobby was located in the first floor of the tower. Nearby were a smoking room and a music room. (Sue Maden Collection.)

The town pump was originally on this site, followed by a horse trough. This ornamental structure, however, only houses a drinking fountain. Built in 1896, it was ordered removed in 1912. (Jamestown Historical Society Collection.)

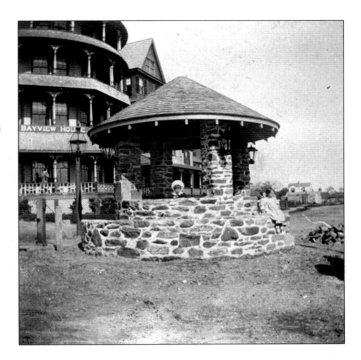

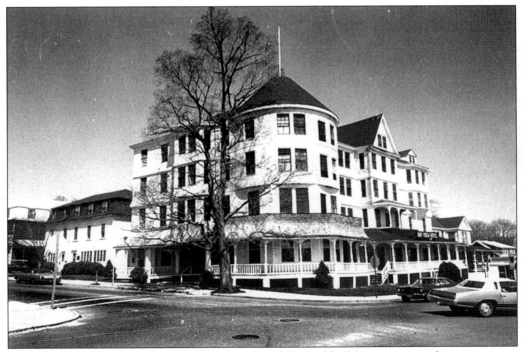

The Bay View had stopped being a hotel in the 1960s and had been converted to apartments by the time of this 1980 view. The tower had been truncated and the porches removed. The building was destroyed in 1985 and replaced by the Bay View Condominiums, a building with somewhat similar massing. (Jamestown Historical Society Collection.)

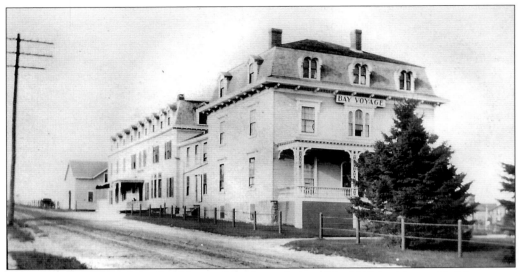

The original section of the Bay Voyage Hotel was designed in 1860 by George C. Mason as a country house in Middletown. In 1889, it was moved to Jamestown by barge to become the Bay Voyage Hotel. The next year, an addition with 30 rooms brought the total rooms to 40. After a 1987 renovation, the Bay Voyage reopened as a time-share resort and hotel. (Linda A. Warner Collection.)

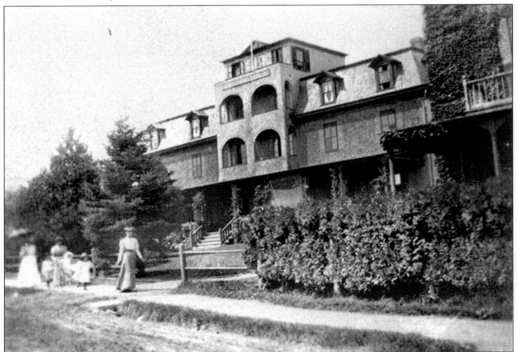

Built in 1888 on Green Lane, this hotel was known at different times as St. James Manor, Carter's Inn, and Prospect House. It was one of a number of smaller hotels and guest houses that offered accommodation away from the ferry landing. The hotel was destroyed in 1923, a casualty of the growing preference for cottages. (Jamestown Historical Society Collection.)

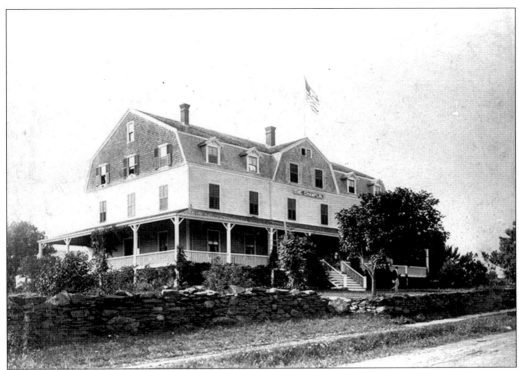

The Champlin, located on Conanicus Avenue across from the Bay Voyage Hotel, was built in 1890 as an inn with accommodation for 75 guests. In 1910, Dr. W. Lincoln Bates bought the hotel to be part of his sanitarium and changed the building's name to Maplewood. (Jamestown Historical Society Collection.)

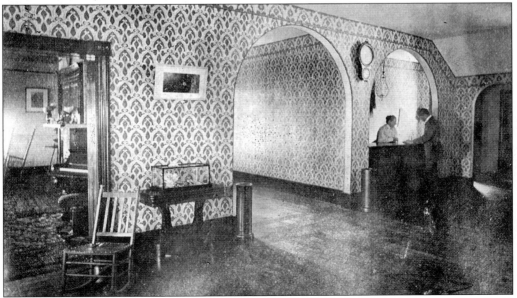

This interior view of the Champlin shows the lobby and front desk and an example of bold turn-of-the-century wallpaper. (Sue Maden Collection.)

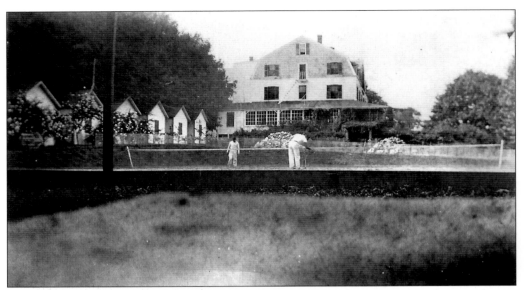

Maplewood, the main building of Dr. Bates's sanitarium complex, was operated primarily as a rest home. On the left are cabins used to accommodate patients. In one of the buildings, Dr. Bates offered electrotherapy to treat a wide variety of illnesses—a service that ended in 1931. A fire that same year, in another building, caused several fatalities. Maplewood itself burned in 1944, and two years later, the cabins were moved to Clarke's Village at Beavertail. (Barbara Magruder Collection.)

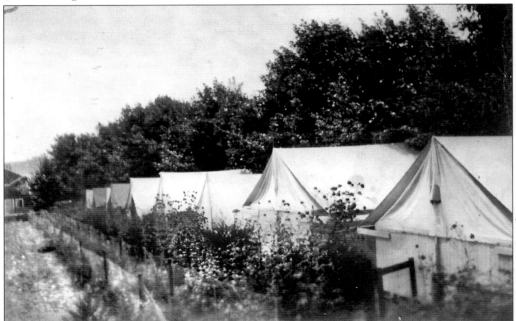

Tents were some of the accommodations at Dr. Bates's sanitarium. Today, it might seem unusual to go to a health facility and be quartered in a tent, but at the turn of the century, fresh air was considered highly therapeutic. In time, the tents were replaced by cabins. (Barbara Magruder Collection.)

William Lincoln Bates started his electropathic practice in Providence. Having spent part of his childhood in Jamestown, he returned to the island in 1898, eventually buying Maplewood and other property. He was the first president of the Jamestown Historical Society, and for many years, the society met at Maplewood. He was also an active member of the local Quaker community. (Barbara Magruder Collection.)

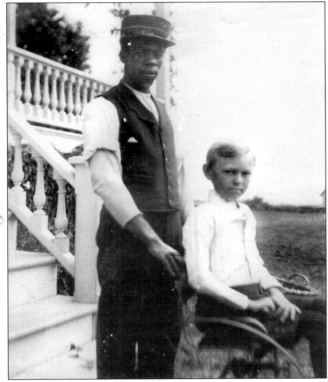

A young patient is shown in this photograph with one of the sanitarium's attendants. The sanitarium advertised treatment of acne, angina pectoris, aphonia, cancer, catarrh, constipation, dyspepsia, epilepsy, infantile paralysis, lumbago, mental diseases, neuralgia, rheumatism, sciatica, and spinal diseases. Types of electrotherapy offered were static, galvanic, faradic, and high frequency, but treatment was not convulsive. (Barbara Magruder Collection.)

Healthy activities such as swimming were part of the regimen at Dr. Bates's sanitarium. The bathhouses that were to be used by patients and guests were identified with the word "Maplewood," which is faintly visible on the roof. (Barbara Magruder Collection.)

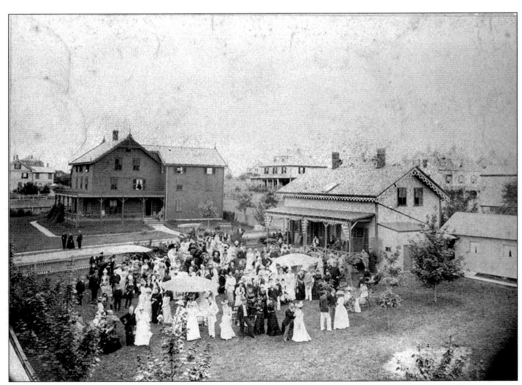

The Jamestown Club was a men's club that operated from a series of rented houses. This c. 1900 view is of a lawn party being held when the club was located on Lincoln Street. (Jamestown Historical Society Collection.)

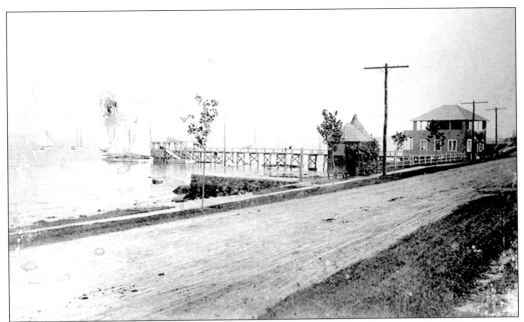

The Conanicut Yacht Club was founded in 1892. Two years later, the pier and clubhouse were erected. The first yacht club in the state, Rhode Island Yacht Club, had been founded in 1877, and by the time of this building, there were only three other clubs on the bay. (Jamestown Historical Society Collection.)

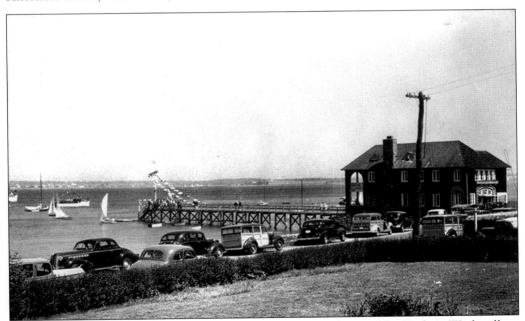

In 1917, the Conanicut Yacht Club built a new clubhouse designed by Herbert Wetherill on the site of the first club. The previous year, the Jamestown Club had merged with the yacht club. Initially, the men's club took over the new building's second floor, which was accessed by a private entrance. (Jamestown Historical Society Collection.)

The Harbor View Inn on Conanicus Avenue was built by Abbott Chandler *c.* 1897. It was designed by Charles Bevins as a less stylish structure than the architect's earlier Thorndike Hotel. Over the years, it served as a boardinghouse for seamen and as a nursing home. It was destroyed in 1984 to make way for the condominiums now on the site. (Linda A. Warner Collection.)

The Shoreby Hill Club was originally located on Priscilla Road, next to the Greene Farmhouse, just barely visible on the right. It was built *c.* 1898 at the start of the Shoreby Hill development as a social club and a place where residents could take meals. In 1911, the building was moved down the hill to Conanicus Avenue and became known as the Casino. (Jamestown Historical Society Collection.)

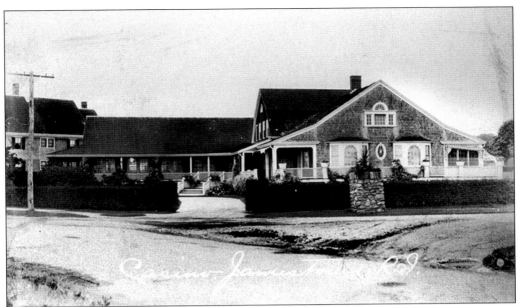

The Shoreby Hill Club was transformed into the Casino, a type of club that was common in Northeast summer resorts—most famously at Newport and Narragansett. Dances and other social activities were the purpose of casinos in this period, rather than gambling. There was a membership fee, but usually anyone could join. Casinos were a transition between the public social environment of the hotels and the private social environment of the country club. (Jamestown Historical Society Collection.)

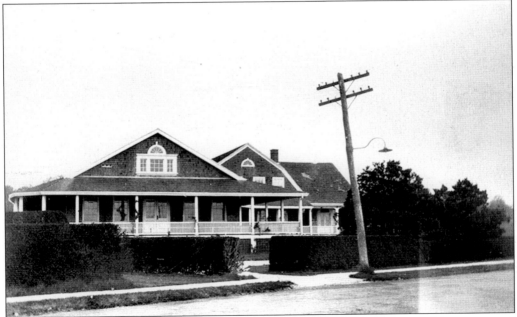

This view of the Casino shows the size of the ballroom, which was the site of dances several times each week in the summer. The ballroom was removed when the Casino was converted to a private residence. (Jamestown Historical Society Collection.)

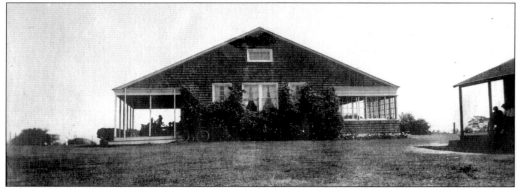

The clubhouse of the Jamestown Golf and Country Club, built in 1902, was originally located on Whittier Road on Shoreby Hill, next to the tennis courts. Other facilities included croquet grounds, a bowling green, and a baseball field. For a time, tea was served in the afternoon. The building, with its porches enclosed, has been moved to Conanicus Avenue. (Jamestown Historical Society Collection.)

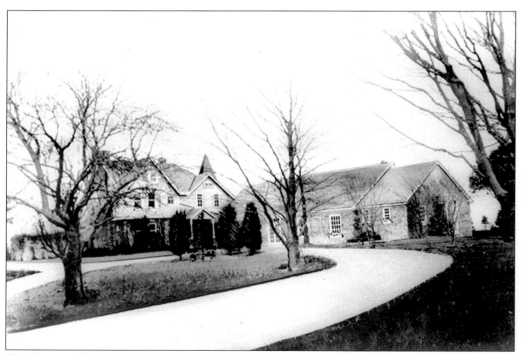

The Beavertail Country Club was established on Audley Clarke's property in 1927, and his father's house, Wyndesweepe, became the clubhouse. Wyndesweepe was built in 1888 to a design of Charles Bevins, and the wing on the right was added as the club's ballroom. The clubhouse was destroyed in the 1940s. (Jamestown Historical Society Collection.)

Four

AN ISLAND COMMUNITY

The plan for Conanicut Island, drawn up in 1657, envisioned a township, but it was not until 1709 that one was laid out. At that time, 20 one-acre lots were given to the owners of the 20 outlying farms, but this did not lead to a rush of house building. The lots were laid out in a line along the north side of the ferry road with a burial ground and artillery lot where the ferry road intersected the main road to the north. The village was slow to develop, and for almost two centuries, most of the land on the island continued to be used for farming. The population of the island varied, but it never exceeded 600 until after 1885.

Eventually, however, the same factors that encouraged the development of Jamestown as a resort would also promote the growth of the village. The same steam ferry that brought the hotel guests and the cottagers also made Jamestown an easier place to do business. In time, even off-island businesses such as J.T. O'Connell, of Newport, and the A & P and First National grocery companies established stores in town. Farmers seemed happy to sell their land at rising prices and invest the proceeds in businesses that would serve the tourists, providing them either with accommodations and goods or with services such as construction and maintenance for their cottages.

The ferry and hotels fostered economic growth, but they also promoted the concentration of the population in the village. When everyone walked, distances were obviously crucial and the hotels were, sensibly, located by the ferry landing. The shops, in turn, were logically near the hotels, and residents who worked in either wanted to live nearby. In 1884, residents, believing that Jamestown had become "a popular summer resort," successfully petitioned the town to change the name of Ferry Road to the more prestigious Narragansett Avenue. Institutions, particularly the churches, congregated on this newly dignified main street. Central Baptist Church was formed precisely to be central. Attendance dwindled at the old Baptist Meeting House on North Main Road, and it was eventually abandoned. St. Mark Parish thought it worthwhile to move its building to Narragansett Avenue from as close by as Clinton Avenue. The eccentric exception to this process of concentration was the Movable Chapel. St. Matthew's Parish had long been on Narragansett Avenue, so it was in a missionary spirit that its minister conceived of a chapel that could serve tourists at Conanicut Park and mid-island farmers as the seasons dictated.

For most of the time, the year-round and summer communities went their separate ways, but they could also come together. Among the most joyful of these occasions was a turn-of-the-century annual celebration involving a parade, sporting events, and other activities for all. Watersports, a day set aside once each summer for various competitive events, came along later and was held at the yacht club.

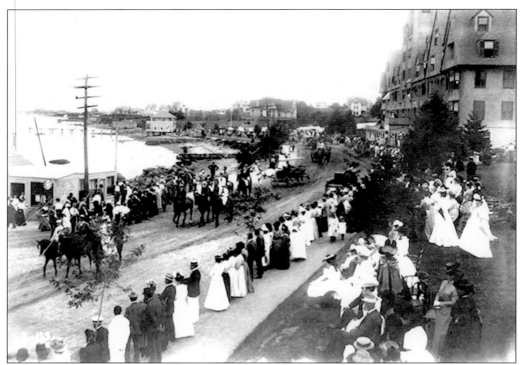

Begun in 1898, Jamestown Day was a holiday that featured a parade of fire equipment, bicyclists, equestrians, decorated carriages, and marchers. Other typical events included dog shows, potato races, baby contests, and dances. (Jamestown Historical Society Collection.)

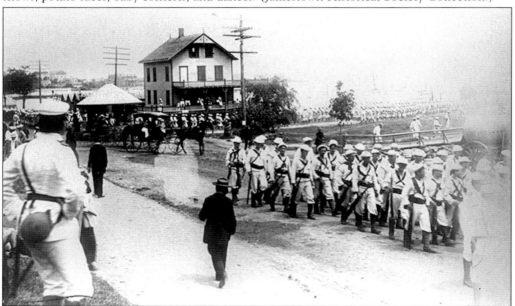

The Jamestown Day parade of August 30, 1900, included the military. In this view, looking north from the Gardner House, the town pump and the Knowles cottage are on the left. (Jamestown Historical Society Collection.)

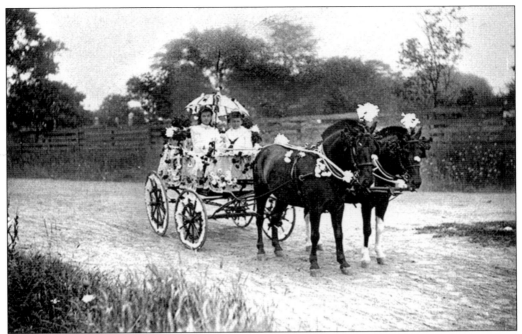

The Hirst children were on their way down Green Lane in 1901 to join the Jamestown Day parade. Prizes were given for the best decorations in various categories. (Jamestown Historical Society Collection.)

Eben N. Tefft, local farmer and businessman, decorated his market wagon for the Jamestown Day parade. (Jamestown Historical Society Collection.)

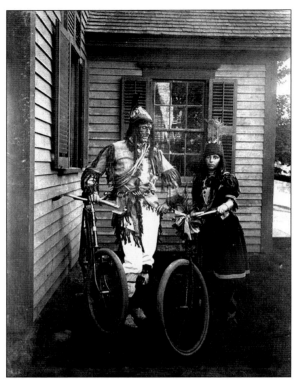

These bicyclists by the town hall wore Native American costumes for the Jamestown Day parade. (Jamestown Historical Society Collection.)

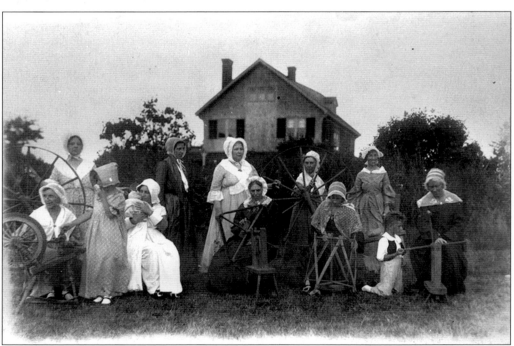

At this celebration of Jamestown Historical Society Day *c.* 1926, women in costume demonstrated various devices for spinning and winding yarn. (Jamestown Historical Society Collection.)

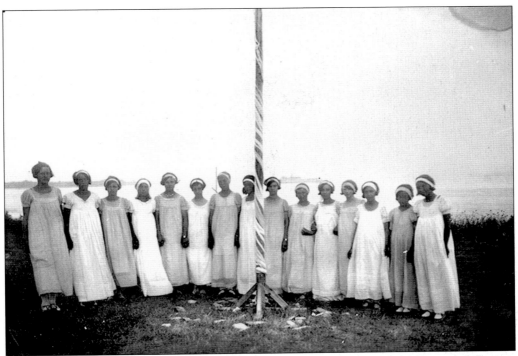

Young women anticipated dancing around the maypole at a Jamestown Historical Society pageant. This event took place at the Keeler House on Walcott Avenue in 1928. (Jamestown Historical Society Collection.)

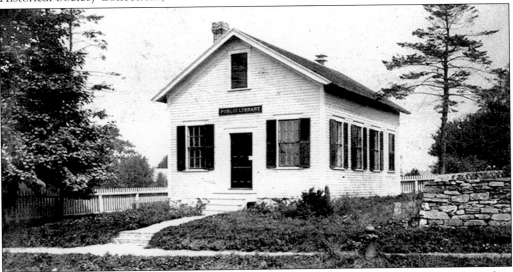

Currently the museum of the Jamestown Historical Society, this building was constructed in 1886 as the primary school. It was originally located on Southwest Avenue and was moved to its present location on Narragansett Avenue in 1898 to become the town library. It remained in this use until the 1971 construction of the present library. This photograph shows the building c. 1900, before the stone wall was built along the sidewalk. (Jamestown Historical Society Collection.)

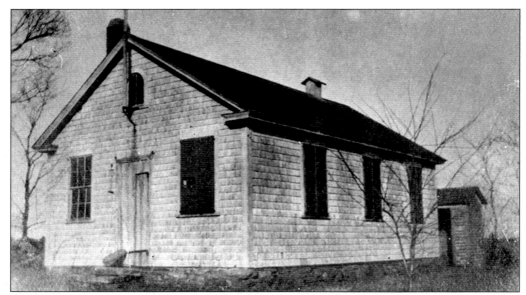

Old North School, much altered but still standing on North Main Road, was built c. 1857 and was used for schooling until 1909. Lucy Gardner, who had attended the school as a youngster, bought the school in 1926. Local contractor Ralph Hull converted it into a summer cottage for her. Ralph had also been a student there, and during the makeover he found, under the teacher's platform, one of his old arithmetic test papers. It was graded 100. (Jamestown Historical Society Collection.)

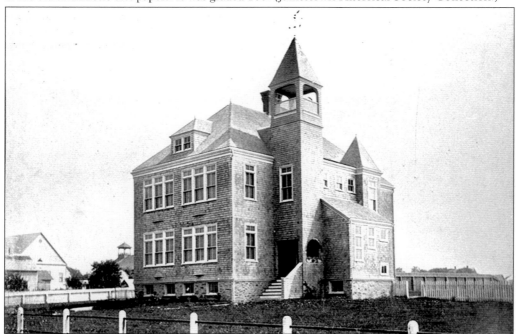

The Carr School was built on Clarke Street in 1897 by George D. Anthony and designed by Newport architect J.D. Johnston. Before subsequent additions, it had four classrooms, each used by two grades. The Carr School was replaced by a new grade school on Lawn Avenue in 1955. McQuade's Market now occupies the site. (Jamestown Historical Society Collection.)

George H. Carr was captain of J.S.L. Wharton's fleet of yachts and was superintendent of Wharton's Ship Yard. He was also involved in the town as a vestryman at St. Matthew's Church, and chairman of the School Committee for 34 years. The Carr School was named for him and a former superintendent, Thomas G. Carr, in 1924, 27 years after the school was built. (Jamestown Historical Society Collection.)

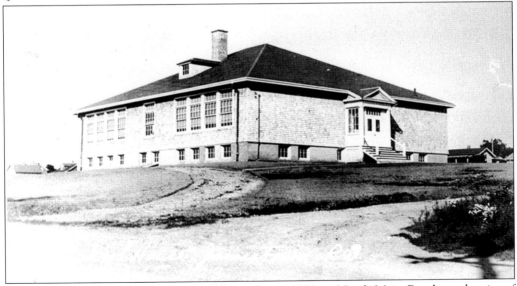

The Clarke School opened for the middle grades in 1923 on North Main Road, on the site of the present library. Named for Thomas Hartwell Clarke, a former school superintendent, the school remained in use until 1955. (Jamestown Historical Society Collection.)

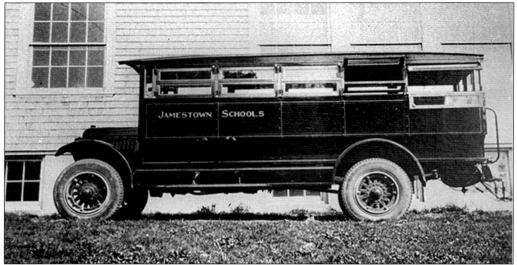

For many years, the town needed only one school bus. This bus, parked by the Clarke School, was in use at the end of the 1920s. (Jamestown Historical Society Collection, original at Newport Historical Society.)

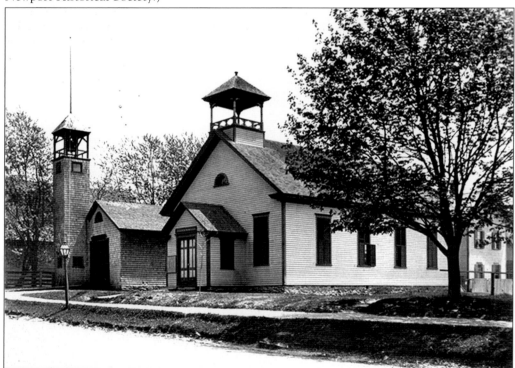

The town hall was built by James D. Hull in 1883 to the design of fellow Jamestown resident John F. Gill. The belfry was removed, perhaps in 1914, when the town clerk's office was added to the front of the building. Later on, the entrance was moved around to the west side. The fire station to the left was built c. 1894 and served the town until 1928, when the present station was completed. (Jamestown Historical Society Collection.)

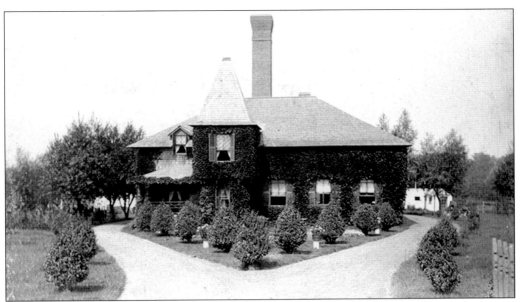

This pumping station of the Jamestown Water Company was located on Southwest Avenue in the building that is now occupied by the town offices. It pumped from two large wells on the property, and the taller chimney provided the draft necessary to fire the boilers that powered the pumps. There was an apartment for the superintendent and his family on the left side of the structure. (Jamestown Historical Society Collection.)

Jamestown has a long history of moving its buildings. In 1928, this post office building, possibly the island's eighth, was pulled up Narragansett Avenue by the town steamroller to Melrose Avenue, where the structure was converted to a residence. In the foreground was a telephone company truck to assist with the move. (Jamestown Historical Society Collection.)

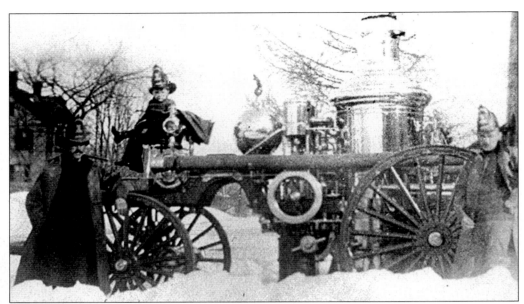

Jamestown's first fire engine was a horse-drawn American LaFrance steam pumper. It was purchased in 1894 and was used until 1930. Pictured, from left to right, are William Arnold, Daniel Oxx Jr., and Daniel Oxx. The fire engine has been restored and is now in the Memorial Museum next to the fire station. (Jamestown Historical Society Collection, original at Newport Historical Society.)

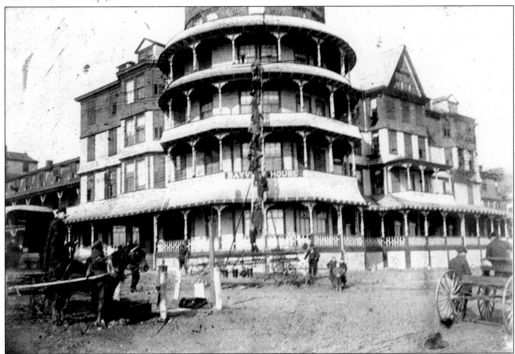

Firefighters are practicing the use of the new hook-and-ladder truck that was purchased in February 1892. (Jamestown Historical Society Collection.)

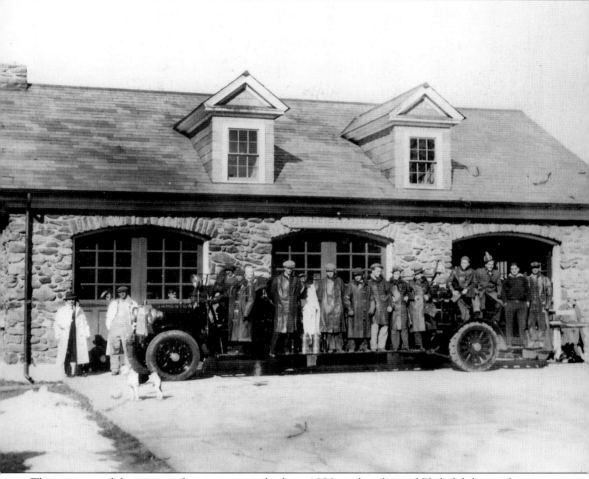

This portion of the present fire station was built in 1928 to the plans of Philadelphia architect Herbert J. Wetherill. Although never realized, the original plans called for this fire station to be the western wing of a porticoed municipal building also housing the police station, library, and town clerk's office. Instead, the firehouse has been expanded to the east and a second story added. Standing to the left are Chief Jesse Tefft (left) and Assistant Chief Everett Tefft. Also included in the photograph are Tim McGrath, Ernest Vieira Sr., Foster Caswell, Gene Kirby Jr., Fred Stillman, Harold Richardson, Dan Murray, Harry Shatzer Jr., Frank Barry, Neil Lyons, and Walter Marley. (Jenny Clarke Collection, Newport Historical Society.)

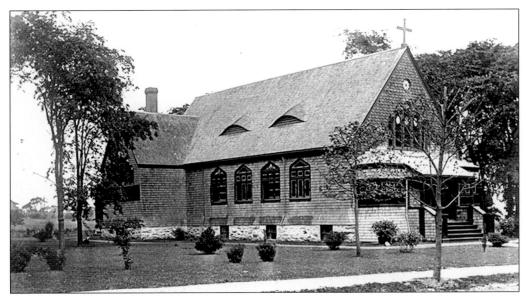

The former Chapel-by-the-Sea was built on Clinton Avenue in 1893 and was moved in 1909 to Narragansett Avenue. In that same year, the church stopped being a mission of St. Mary's in Newport and acquired its own priest and a new name: St. Mark Church. The design, by Charles Bevins, had patterned shingling and eyebrow dormers—features typical of the period. In 1959, the building was replaced by a larger church. (Jamestown Historical Society Collection.)

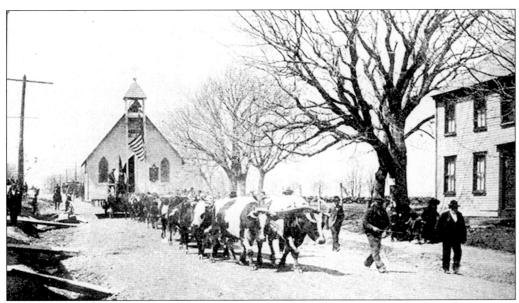

The Movable Chapel of the Transfiguration was built in 1899 by St. Matthew's to provide services for the summer residents of Conanicut Park. The plan was that in the winter the chapel would be moved to a location suited to farmers some distance from the church in the village. The chapel proved more difficult to move than expected, and it remained stationary for about 30 years before being moved back to town to become a residence. (Jamestown Historical Society Collection.)

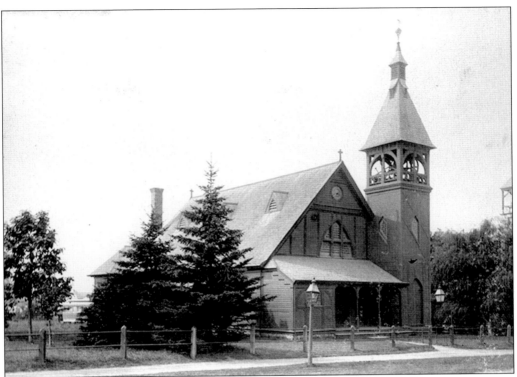

St. Matthew's Episcopal Church was built by Gordon Oxx and designed by Newport architect George C. Mason Jr. in 1880. While many remember the church as shingled, it was apparently originally clapboarded in the Stick style, with wooden ornamentation to mimic the underlying structure. The design of the belfry was consistent with this style. (Jamestown Historical Society Collection.)

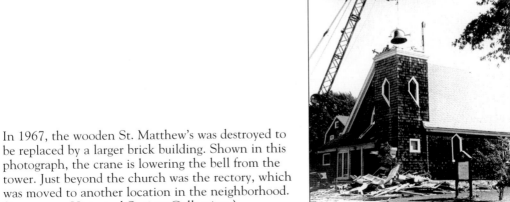

In 1967, the wooden St. Matthew's was destroyed to be replaced by a larger brick building. Shown in this photograph, the crane is lowering the bell from the tower. Just beyond the church was the rectory, which was moved to another location in the neighborhood. (Jamestown Historical Society Collection.)

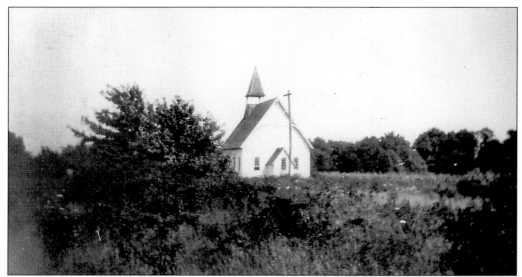

The rationale for the Movable Chapel was not compelling because Conanicut Park already had a nondenominational chapel. The Union Chapel, built in 1886, was constructed in a Victorian Gothic board-and-batten style appropriate to the cottages that were being built in the park. (Jamestown Historical Society Collection.)

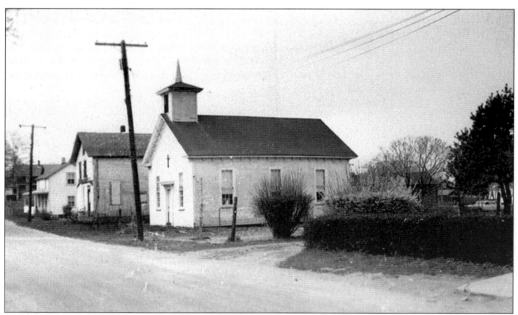

This church was built in 1868 for the Baptists at the corner of Narragansett and Southwest Avenues. An earlier meetinghouse had been on North Main Road near Carr Lane, but the location was too remote from the village. To make room for the present Baptist church, this building was moved in 1890 to Cole Street, where it became an African Methodist Episcopal church. It was abandoned in the 1950s and was subsequently converted into a residence. (Jamestown Historical Society Collection.)

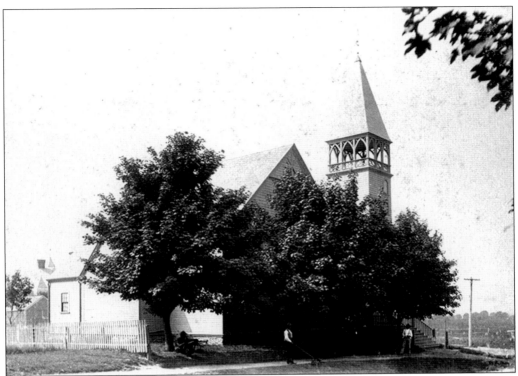

Central Baptist Church was built in 1891 at the Four Corners, replacing a smaller structure. The Stick-style design by Adolphus Knowles had an off-center tower, a design similar in concept to St. Matthew's Church. Central Baptist Church is the only survivor of the handsome trio of churches that once graced Narragansett Avenue. Its prominent tower, damaged by storms, has been removed. (Jamestown Historical Society Collection.)

West of the Four Corners, Narragansett Avenue in 1890 had light traffic and few buildings, but there was a street light at the intersection. The house in the distance is Thorncroft, built in 1860, the home of John J. Watson, a gentleman farmer who was active in local and state government. (Jamestown Historical Society Collection.)

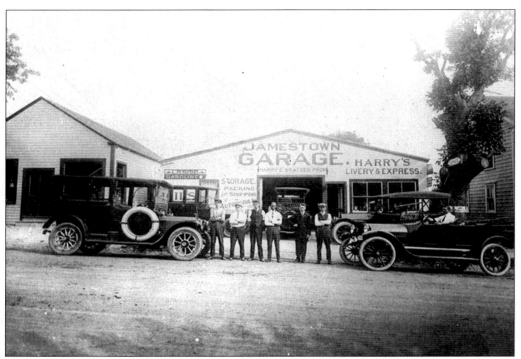

The Jamestown Garage, built in 1911 by Ferdinand Armbrust, was used by many summer visitors to garage their cars. While Harry Shatzer owned the garage from 1913 to 1916, it was later run by the Moll family for about 80 years. Standing, from left to right, are John Moll, Harry Shatzer, Charlie Moll, William Youngblood, and Jack McKnight plus two unidentified men. (Jamestown Historical Society Collection, original at Newport Historical Society.)

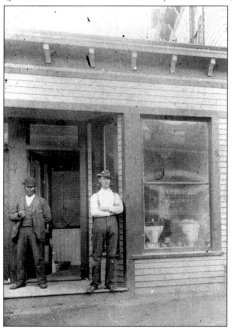

Ferdinand Armbrust stands at the entrance to his plumbing shop, where the latest commodes are displayed in the window. The building is now occupied by Jamestown True Value Hardware. (Jamestown Historical Society Collection.)

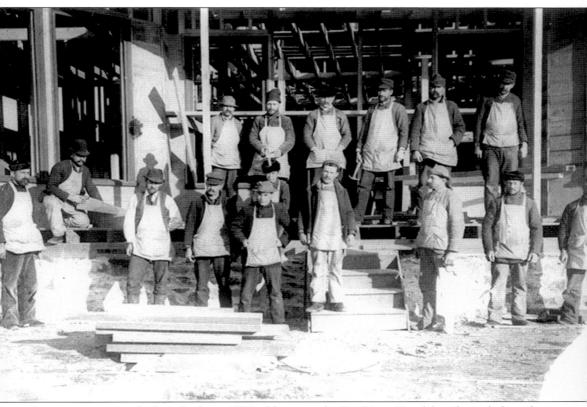

These carpenters worked on the large 1889 addition to the Bay View Hotel for what is believed to have been 10-hour days, earning 20¢ per hour. Pictured at the main entrance are, from left to right, the following: (front row) A.C. Knowles, unidentified, William Knowles, Will Gardner, Will Caswell, (behind) unidentified, Harry Nason, H. Knowles, and Jerry Tefft; (back row) Edwin Knowles, unidentified, Henry Knowles, Roderick McDonald, unidentified, and Jim Hull. (Jamestown Historical Society Collection, original at Newport Historical Society.)

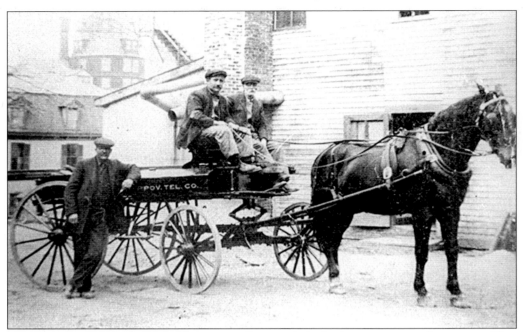

The Providence Telephone Company initially provided telephone service to Jamestown. This crew is behind the Gardner House, the location of the town switchboard. The tower of the Bay View Hotel is visible in the background. (Jamestown Historical Society Collection.)

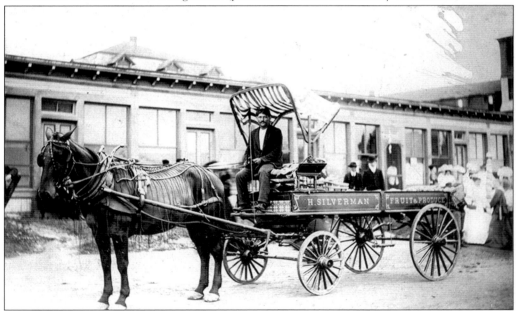

H. Silverman advertised fruit and produce on his wagon, and his customers expected him to stop at their houses several times each week. He is pictured in front of the Caswell Block, which replaced Albert Caswell's Riverside House, destroyed by fire in 1894. The Caswell Block (later known as the Hunt Block) was itself replaced in 1981 by commercial-residential condominiums. (Jamestown Historical Society Collection.)

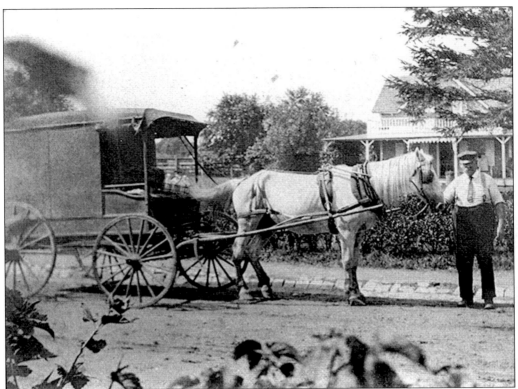

Benjamin E. Hull delivered milk from his farm in the North End. He is seen here on Green Lane with his milk wagon *c.* 1915. The Gothic cottage behind him was built in 1884 for Mrs. A.C. Greene by William A. Champlin. (Jamestown Historical Society Collection.)

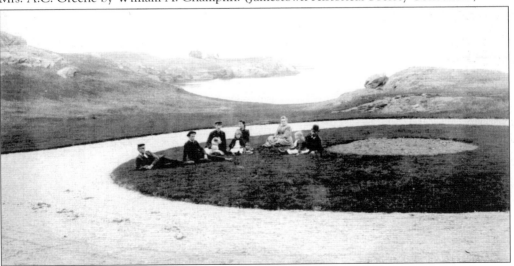

An important source of employment on the island was the maintenance of the summer houses. The Soule family, caretakers of Horsehead for many years, poses in the drive. Charles Soule, on the right with his daughter Ethel, was related to members of the Clarke family. The Charles Wharton and Shoemaker houses are in the distance. (Wright Collection.)

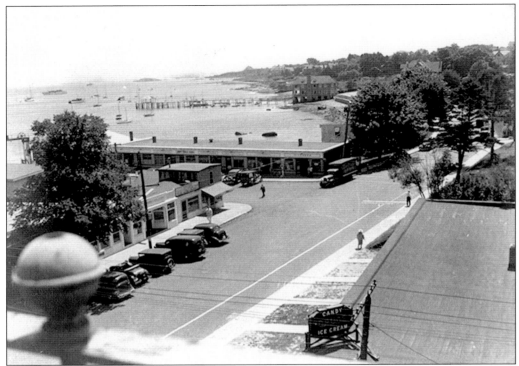

In this picture taken from the top of the Bay View Hotel, the Horgan Block can be seen on the left. Over the years, in addition to local merchants, off-island firms such as J.T. O'Connell and A & P occupied buildings in the Horgan Block. The block deteriorated during the Great Depression, and the town bought part of the property to revitalize it. Demolition was completed just before the 1938 hurricane would have done the job for free. (Jamestown Historical Society Collection.)

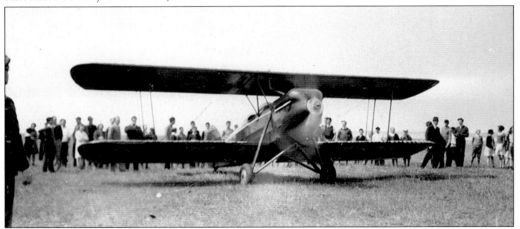

On May 19, 1938, a ceremony marked the inauguration of airmail postal service. Jamestown became a stop on a route that connected several Rhode Island towns to Hillsgrove State Airport, now T.F. Green Airport. The landing strip was at Beavertail, and Postmaster Samuel W. Smith III gave the first airmail pouch to the pilot of this plane. (Jamestown Historical Society Collection.)

Five

THE ARCHITECTURE
OF SUMMER

The first group of houses in Jamestown to be built for summer use was at Conanicut Park in the 1870s. The developer was not indifferent to the style of architecture employed by the lot owners, since it had to be approved by the company. The company liked Gothic Revival, which was not surprising, since a model for the development had been Wesleyan Grove on Martha's Vineyard, a Methodist camp of diminutive Gothic cottages. By the 1880s, however, the Shingle style was evolving in resort areas of the Northeast. The Shingle style was a reaction to Victorian heavy-handedness and reflected nostalgia for the simpler times of our Colonial past. The nostalgia had been fostered by the 1876 Centennial Exhibition in Philadelphia and resulted in a renewed interest in gambrel and saltbox roof forms, dormers, multipaned windows, and shingle-clad exteriors. The Shingle style updated these elements with free-flowing floor plans that used porches extensively to create outdoor rooms. Also important were the asymmetries of the Queen Anne style, as well as such specific picturesque features as turrets and bay windows.

The foremost proponents of the Shingle style were McKim, Mead, and White, who in 1881 had completed the influential Newport Casino. They proceeded to design a large number of Shingle-style houses in Newport and other resorts. Three houses in Jamestown have been attributed to the firm. Jamestown, however, had Charles L. Bevins (1844–1925) as its own Shingle-style architect. Bevins emigrated from New Brighton, England, in 1879 and moved to Boston. Interestingly, New Brighton was a Victorian seaside resort sharing some similarities with Jamestown. It was reached by ferry (from Liverpool) and had a lighthouse and a historic fort. After working with Peabody and Stearns and other architects in Boston, Bevins moved to Jamestown in 1882. He became associated with Dan Watson, a real estate agent who represented the Ocean Highlands Company among others. It is presumed that Watson encouraged his clients to use Bevins for their houses, accounting for a profusion of his designs in the Dumplings and Walcott Avenue areas. Bevins's designs are individualistic, most differing significantly one from another. He favored geometric variety, which he achieved with such features as paired gables, towers, and Oriental lattice motifs. To date, 40 buildings in Jamestown have been identified as the work of Charles L. Bevins.

Another local architect was J.D. Johnston, who started as a carpenter, became a contractor, and eventually practiced as an architect. Given the breadth of his skills, it is sometimes difficult to know just what role he had in a building. Like Bevins, Johnston was sensitive to the way buildings integrated with their sites, the most spectacular of which was doubtless the "dumpling" on which he built Clingstone. He favored low-pitched roofs and broad eaves, giving his houses a sheltering look. Shingle-style architects with national reputations did not typically work in Jamestown, but it should be noted that Wilson Eyre of Philadelphia did build Grey Ledge on Beavertail. Better known is his St. Columba's Chapel in Middletown. The result of this flowering of the Shingle style, just as the island was becoming established as a resort, is one of the most remarkable collections of buildings of the genre in the Northeast.

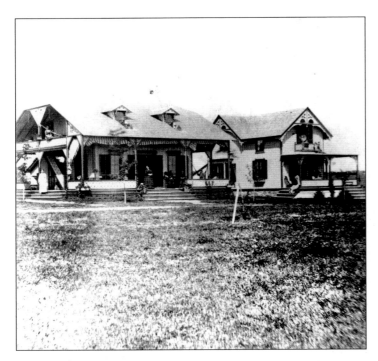

The Shurtleff cottage (left) was built in 1875 in Conanicut Park. Its clipped gables, board-and-batten siding, and Chalet-style upper porch all help to distinguish it from the typical Conanicut Park cottage next to it. (Newport Historical Society Collection.)

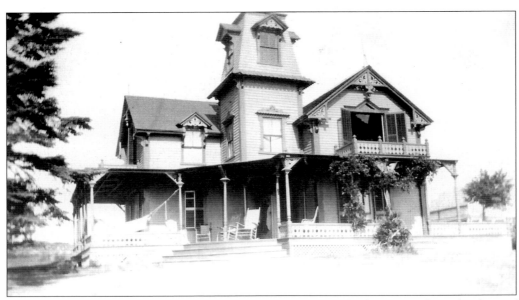

The Jennie Lippitt House, known as Stonewall Cottage, was built in 1873 by a daughter of Gov. Henry Lippitt, who was a founder of Conanicut Park. The most prominent feature of the house is its square mansard tower with four dormers. (Jamestown Historical Society Collection.)

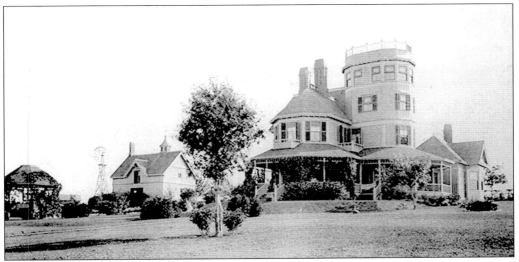

This handsome house was built in 1885 by Charles Fletcher, a wealthy textile manufacturer from Providence. Its scale, prominent tower, extensive grounds, and outbuildings were unusual in Conanicut Park. In 1915, the house became the Point View Hotel and, later, the Jamestown Inn. The house had been divided into condominiums but was recently restored as a single-family house. (Jamestown Historical Society Collection, original at Newport Historical Society.)

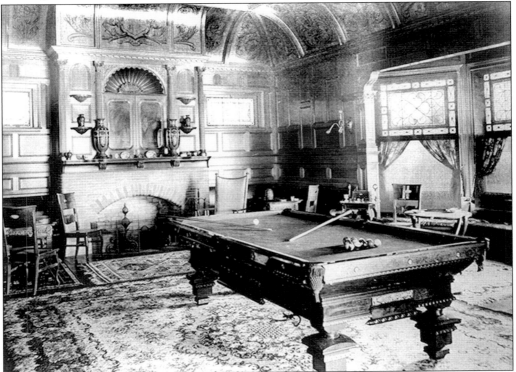

The billiard room of the Fletcher House is shown in 1918. It does not have the lightness of interior furnishing or decoration that typified summer houses. The elaborate ceiling and overmantle would be more usual in an urban setting. (Jamestown Historical Society Collection.)

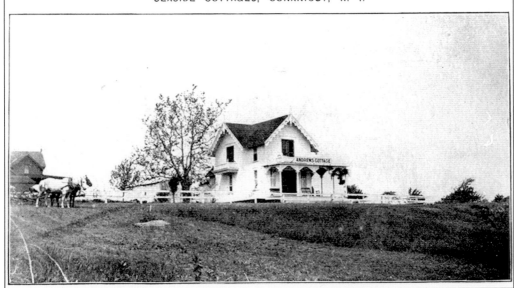

The Andrews cottage in Conanicut Park was built for Bertha J. Luther in 1874–1875 but was subsequently given to Camp Seaside in memory of Elizabeth H. Andrews. It is a classic board-and-batten Victorian cottage with porch brackets and bargeboards. Camp Seaside was run by the Providence YWCA, which first came to Conanicut Park in 1878. (Jamestown Historical Society Collection.)

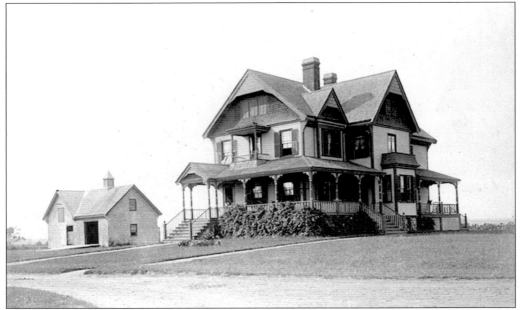

This house and carriage barn on Mount Hope Avenue were built by Adolphus Knowles as a rental cottage for his brother Edwin Knowles. Although it was built in 1889, at the height of the popularity of the Shingle style, this house is restrained and has none of the easy flow of its shingled contemporaries. (Jamestown Historical Society Collection.)

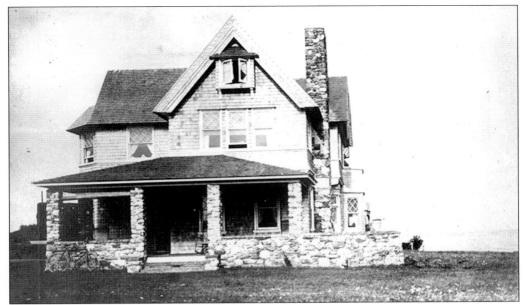

Spindrift, on Bay View Drive, was built between 1896 and 1897 for A. Lawrence Wetherill of Philadelphia. It is an appealing composition of gables, shingled cornices, and diamond-pane windows. The stone porch was long ago extended and enclosed. It is attributed to Stanford White. (Jamestown Historical Society Collection.)

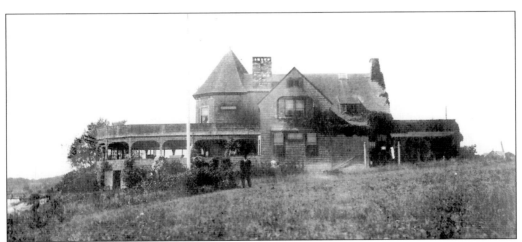

The Buffum cottage stood just north of Spindrift on Bay View Drive until it was destroyed in the 1940s. It was designed by Charles Bevins and built between 1891 and 1892 for the Reverend S.H. Gurteen of Buffalo, but for many years it belonged to the Buffum family. It was most remarkable for its two-story porch that projected to the bay. The porch, about 30 feet in diameter, appeared circular, although it was probably 16 sided. (Jamestown Historical Society Collection.)

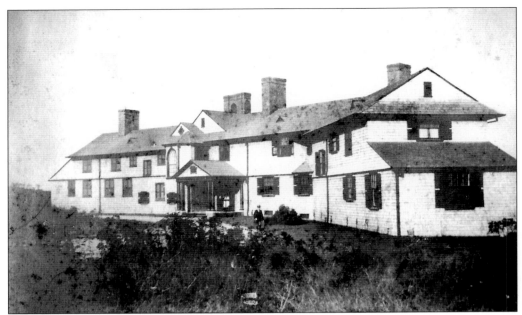

Shoreholme belonged to John M. Whitall, of Philadelphia. Built in 1899 on Bay View Drive north of the Buffum cottage, this very long house was an arc facing the water, providing a variety of water views. Shoreholme was torn down in 1934. (Jamestown Historical Society Collection.)

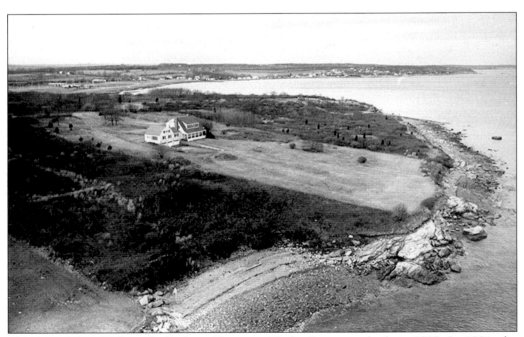

The Rear Adm. William R. Furlong House on Taylor Point was built in 1928. In 1981, the main house was moved to Conanicus Avenue to make way for the time-share development Newport Overlook. The addition to the left was added on to another Bay View Drive house. (Jamestown Historical Society Collection.)

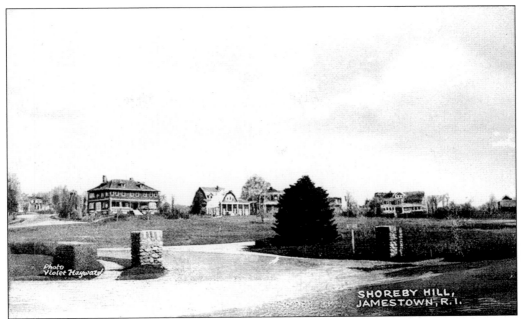

Beginning in 1895, the Greene Farm was developed into Shoreby Hill by summer residents from St. Louis. The design was done by Ernest Bowditch, who had laid out Tuxedo Park, New York. Initially the semicircular green was to have 13 house lots, but the lots were bought up by abutters to protect their view. Prominently featured attractions of the development were macadamized roads and a proper sewer system, as well as a pier and bathhouses. (Jamestown Historical Society Collection.)

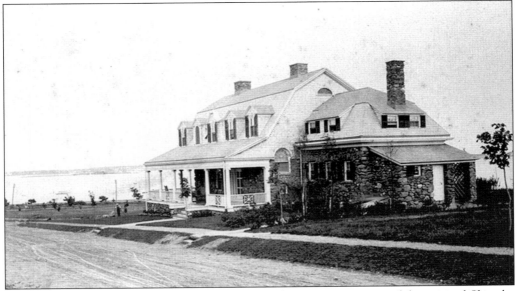

Edward Mallinckrodt, owner of a St. Louis chemical company, was one of the original Shoreby Hill residents, building this Colonial Revival house in 1899. This high-style composition of fieldstone and shingle is distinctive in the neighborhood for its neo-Georgian detail. (Jamestown Historical Society Collection.)

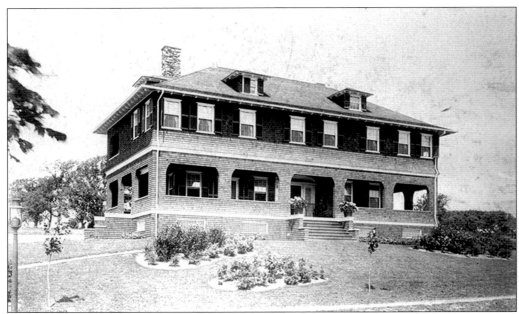

The Red House on Shoreby Hill was built in 1898 to a Creighton Withers design for Mrs. H.S. Potter of St. Louis. Extensive porches were recessed within the shingled skin of the house on the first and the second stories. The Withers firm also designed the clubhouse of the Jamestown Golf and Country Club, which similarly had recessed porches on three sides. (Jamestown Historical Society Collection.)

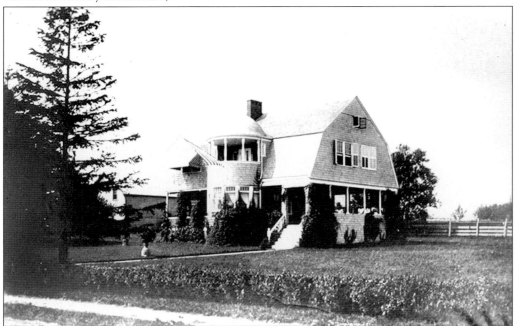

This 1895 cottage was built on Green Lane for William Allison of Philadelphia. It has such typical Shingle-style characteristics as a round tower with open loggia, intersecting roof forms, and an asymmetrical facade. (Jamestown Historical Society Collection.)

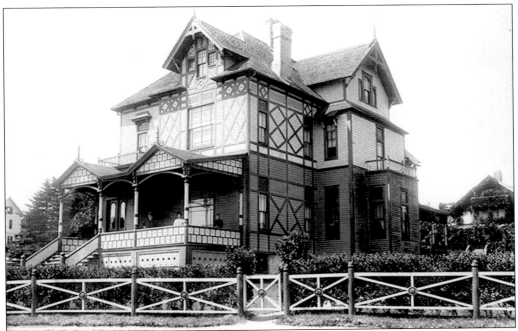

The Albert Caswell house was built *c.* 1892 on the corner of Brook Street and Conanicus Avenue. It is built in the Stick style, in which exterior ornamentation suggests the underlying structure, notably in the diagonal trim reminiscent of bracing. This is a design that was popular several decades earlier, making the house appear to have been built before the 1890s. The house was destroyed in the 1930s and has been replaced by the Sea Chalet condominiums. (Jamestown Historical Society Collection.)

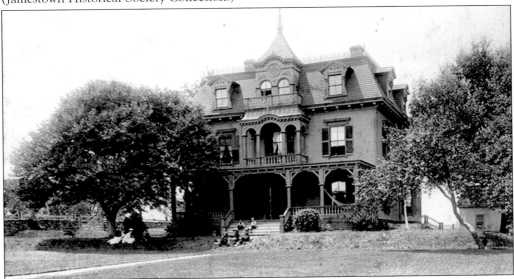

John Howland built this grand house, known as the Howland Mansion, on Old Walcott Avenue in 1875 on the profits of subdividing the family farm. It sits on the site of the original farmhouse. George C. Mason used the same design scheme that he had earlier used on a house on Kay Street in Newport. (Jamestown Historical Society Collection.)

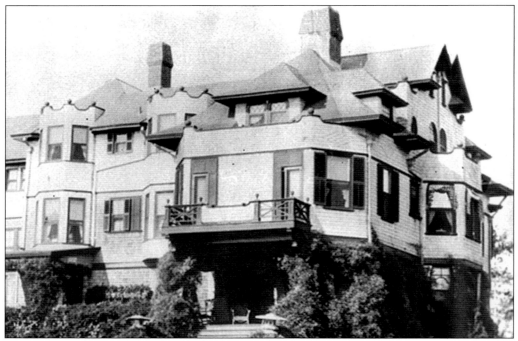

Mira Vista, John Price Wetherill's house, was razed in 1938 in order to extend and widen Walcott Avenue, a military project to improve access to the forts. The studio and playhouse have been converted to private residences. (Jamestown Historical Society Collection.)

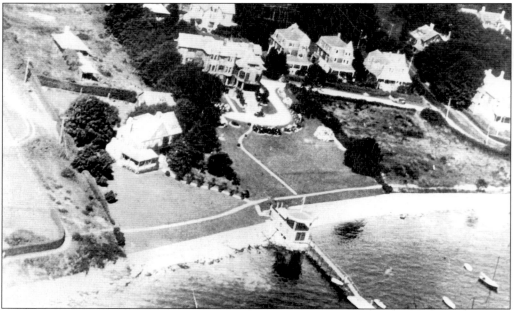

This view shows the area south of East Ferry where Walcott Avenue now climbs the hill after passing Brook Street. In the center is the John Price Wetherill House before it was razed for the extension of Walcott Avenue. Just to the right are three rental houses of P.H. Horgan. At the bottom are the Wetherill dock and boathouse, as well as Jamestown's Cliff Walk. (Coxe Collection.)

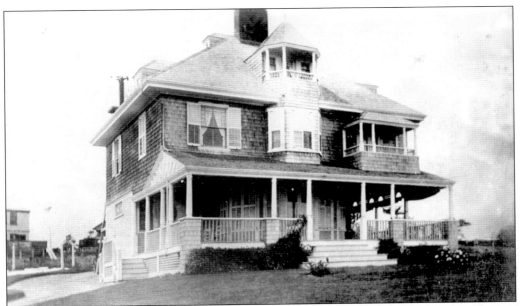

This 1890 house was built for Maj. Clinton B. Sears of the U.S. Army Corps of Engineers. It was designed by Charles Bevins, who frequently used vertical elements like the bay rising to the roof, with a loggia at the top. The house has an excellent collection of stained-glass windows. (Jamestown Historical Society Collection.)

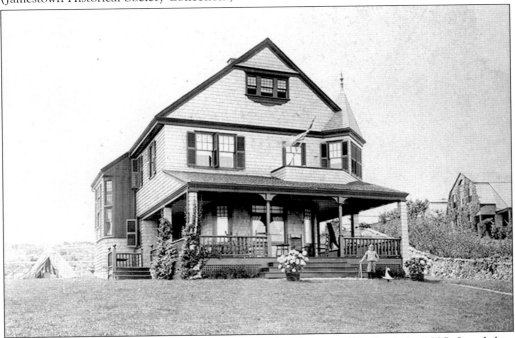

Le Cadeau, on Walcott Avenue, was built for John Carton of St. Louis in 1895. It exhibits many of the features of Bevins houses: a prominent stair window, an angled bay window, a second-story porch, and characteristic moldings under the gable window. (Jamestown Historical Society Collection.)

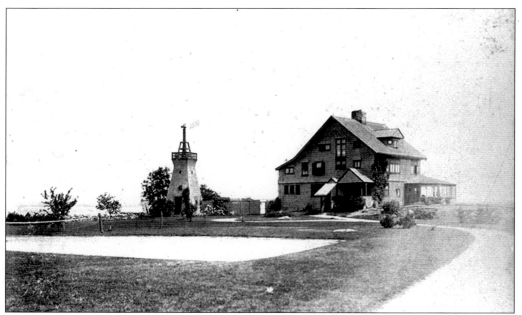

John P. Green, a vice president of the Pennsylvania Railroad, built Anoatok in 1889. Green's pier, located at the Cottrell Farm Association beach, was constructed for his yacht. This Bevins design characteristically has the gable end facing the street. The house has been remodeled several times but retains its Shingle style qualities. (Jamestown Historical Society Collection.)

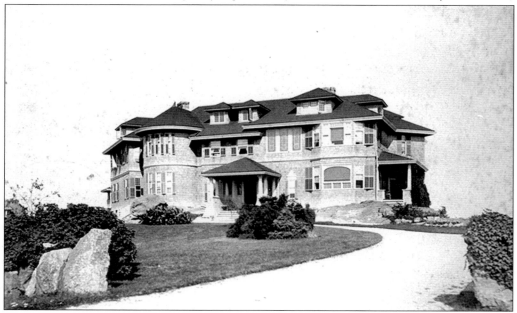

Onarock was built in 1896 for Samuel W. Woodward, an owner of the Woodward and Lothrop department store in Washington, D.C. Designed by J.D. Johnston, the house has strong horizontal massing, which integrates the structure with its site. The use of a round tower to join an angled wing to the main block was a device used by McKim, Mead, and White and others. (Jamestown Historical Society Collection.)

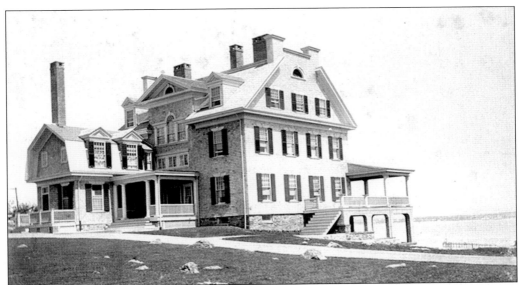

In 1899, Charles W. Bailey, of the Philadelphia jewelers Bailey, Banks, and Biddle, built this confident neo-Georgian house designed by Charles Bevins. The last known design of the architect, it differs from his earlier informal, asymmetrical houses. It is inventive, nevertheless, with its entrance pavilion and projecting gambrel service wing. The tall chimney on the left was for the electric generating plant. The stable and garage survive on adjoining properties. (Jamestown Historical Society Collection.)

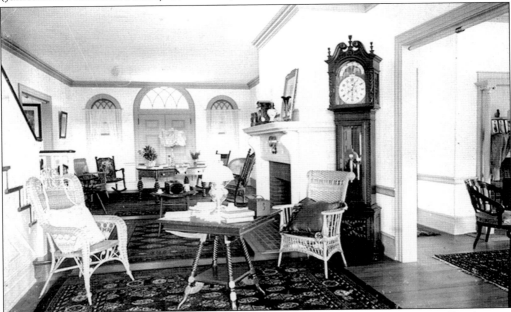

The front hall of the C.W. Bailey House seems to be furnished more casually than its architecture might warrant. Wicker furniture was used extensively in the period and connoted an elegant, relaxed atmosphere, while being cool, comfortable, and easy to move. It was also associated with the Orient and, therefore, was considered exotic and fashionable. (Jamestown Historical Society Collection.)

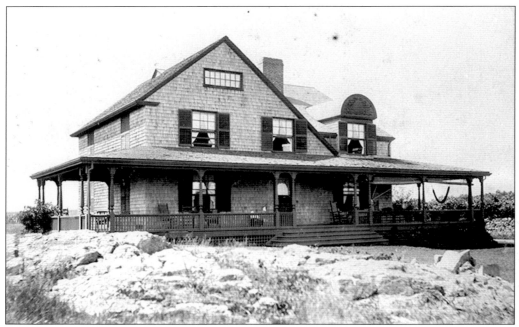

Adm. Seaton Schroeder built Stoneseat in 1888. The architect, J.D. Johnston, incorporated a prominent scallop shell design in a round-headed dormer, a motif perhaps deriving from Newport furniture. (Jamestown Historical Society Collection.)

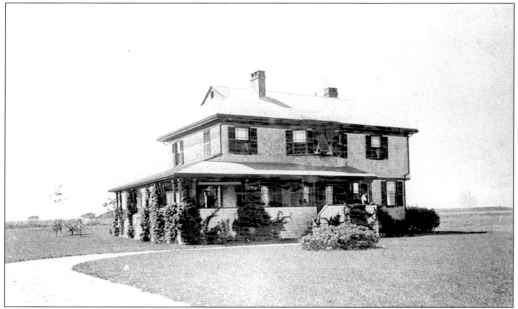

The Elizabeth Clark House of 1896 is the best documented of Charles Bevins's commissions, with plans, correspondence, and receipts recently donated to the Jamestown Historical Society. Miss Clark, from Cambridge, Massachusetts, was secretary to Alexander Agassiz, the noted scientist who owned Castle Hill in Newport. Her secretarial abilities likely contributed to the survival of these documents. (Jamestown Historical Society Collection.)

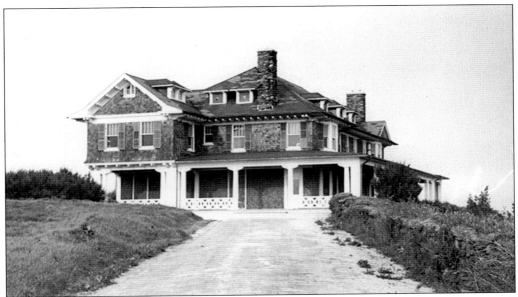

Alta Mira was built in 1905 for William P. Henszey, chief engineer and managing partner of Baldwin Locomotive in Philadelphia. The commanding site provides a panoramic view of the bay and ocean. Designed by Selfridge and Obermaier of New York, the house has a relaxed, informal air that reflects the change of taste at the beginning of the 20th century. A stable below and a boathouse on the shore complete the estate. (Jamestown Historical Society Collection.)

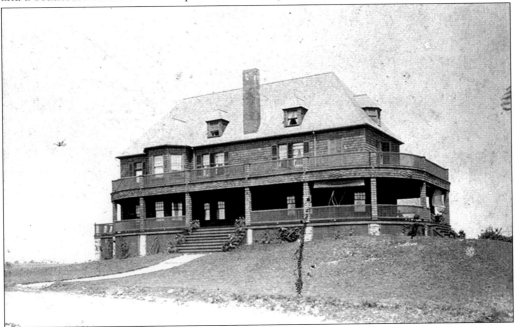

This c. 1910 view shows a house that existed in the vicinity of 215 Walcott Avenue. It is one of two houses built for Dr. T.C. Potter of Germantown. Known as the Road House, it was probably built in 1907. The hip-roofed design with dormers is enhanced by an exceptionally large two-story porch. (Jamestown Historical Society Collection.)

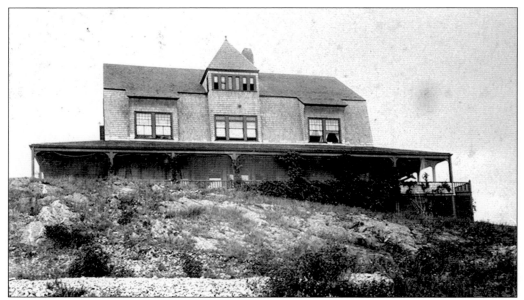

Wawbeck, located on Fort Wetherill Road, was built in 1890 for Maj. Harry Potter of Philadelphia. This Charles Bevins design is somewhat unusual in that it is a gambrel-roofed house with a tower. Bevins liked vertical elements and frequently added towers to his buildings. A porch that wraps around three sides of the house is also typical of the architect. The house has undergone contemporary renovations. (Jamestown Historical Society Collection.)

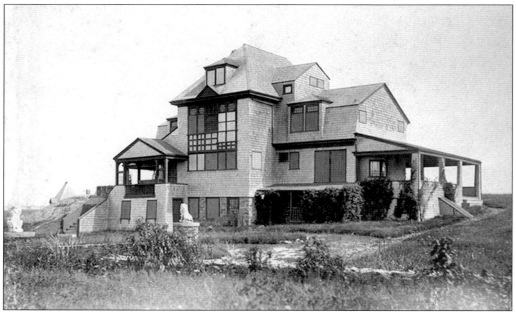

Gen. Robert Patterson in 1888 built this house originally called the Ramparts, but subsequently known as Channel Bells. The geometry of this house is complex, with Charles Bevins bringing together gable, saltbox, gambrel, and hip roof forms along with a wide array of windows, including, most notably, the dominant stair window with a lattice motif. (Jamestown Historical Society Collection.)

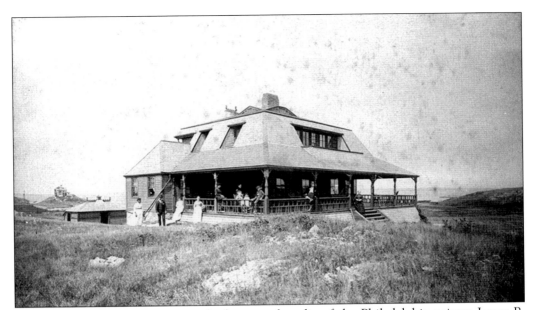

This Newport Street cottage was the home and studio of the Philadelphia painter James B. Sword. Built in 1884, it has been attributed to Charles Bevins and was compared at the time to "an East Indian bungalow." The house was completely overbuilt c. 1905 to a design by J.D. Johnston. (Jamestown Historical Society Collection.)

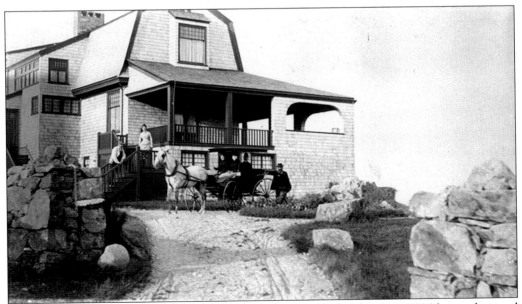

Dr. and Mrs. R. Eglesfeld Griffith are seen on the stairs of Eglesfeld, their 1886 house designed by Charles Bevins. The gambrel end is unusually narrow, but the house breaks out of this form to the left. (Jamestown Historical Society Collection.)

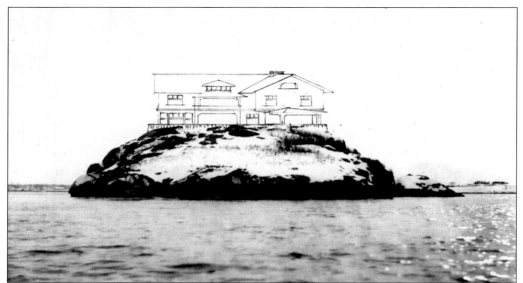

Clingstone, as the house on the rocks is named, was the house built for J.S.L. Wharton, whose earlier house, Braecleugh, was condemned by the U.S. government for the construction of Fort Wetherill. J.D. Johnston is credited as the architect, although both Wharton and his neighbor William Trost Richards had input on the design of the house. Note that the outline on the photograph, likely done by Johnston, is not of the house as built. (Henry Wood Collection.)

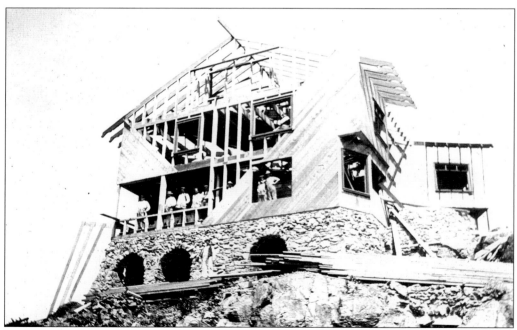

In the early phase of Clingstone's construction, the house is shown with diagonal sheathing. The purpose of this method of building was probably extra strength to counteract the wind on the exposed site. Family history says that the name Clingstone was suggested by James Mapes Dodge's remark to J.S.L. Wharton that he had "a peach of a house." (Henry Wood Collection.)

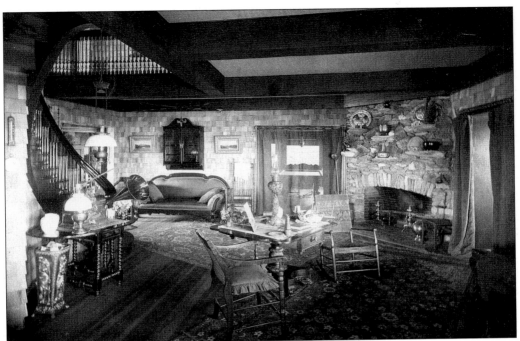

Clingstone had a central hall on its first floor with two unusual features. One was that it was not accessed by a nearby main entry; it was entered by stair from the basement level, where one arrived by boat. The other was that the interior walls were covered by stained shingles, for two possible purposes: to eliminate dampness getting into plaster and to preclude plaster cracking from the reverberations of Fort Wetherill's guns. (Henry Wood Collection.)

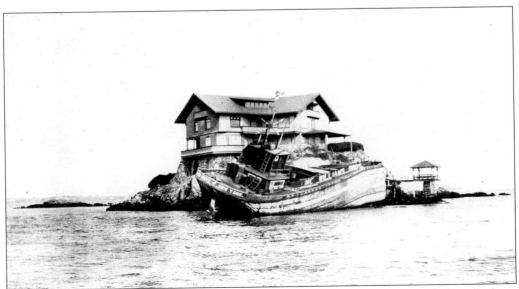

A coal barge went aground at Clingstone c. 1915. The resourceful J.S.L. Wharton is believed to have taken advantage of this new supply of coal by upgrading his heating system. Also visible in the photograph is a teahouse on the right, long since removed by storms. (Henry Wood Collection.)

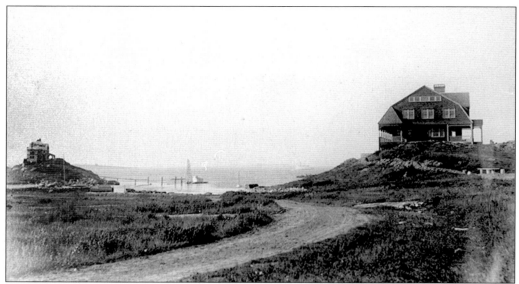

The Dumplings area had extraordinary sites for houses on the rock outcroppings that are scattered about on land as well as just off the shore. Many of the houses that take advantage of these sites were built within a few years of each other in the 1880s. Two such houses, designed by Bevins, were the Barnacle (left), built in 1886, and the Lovering House, built in 1889, which, after significant changes, was known as the Pemberton Cottage. (Jamestown Historical Society Collection.)

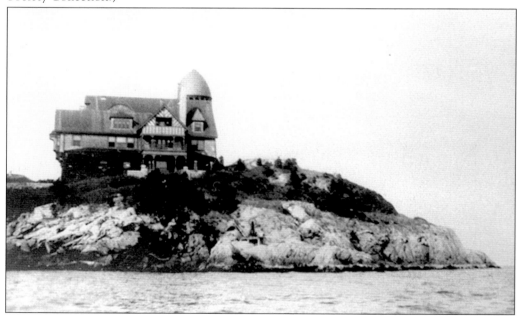

In 1893, Isaac Clothier, of the Philadelphia department store Strawbridge and Clothier, built Harbor Entrance on Bull Point. Because of its tower and spectacular site, it resembled Horsehead, the house of Clothier's friend Joseph Wharton, but the architect, Charles Bevins, had made it quite a different house with multiple bays and gables and half-timbered detailing. The house was torn down in 1967. (Jamestown Historical Society Collection.)

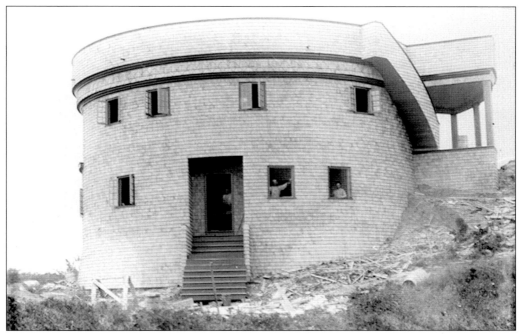

The Round House is shown during its construction in 1888. The inspiration for the Round House is said to have been Fort Dumpling, then existing as a picturesque fortification at the entrance to the bay. Built for Daniel S. Newhall of Philadelphia, the design of the house is attributed to Charles McKim of McKim, Mead, and White. (Jamestown Historical Society Collection.)

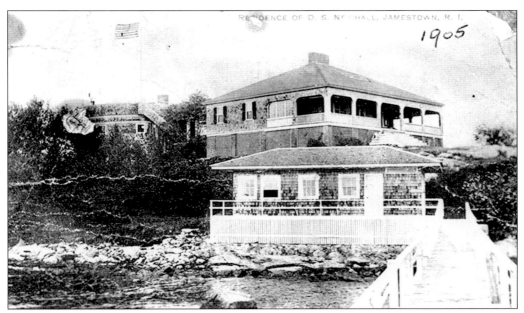

In 1901, the Round House addition, known as the Square House, was attached to the main house by a covered walkway. In 1991, the Square House burned down and was not rebuilt. (Jamestown Historical Society Collection.)

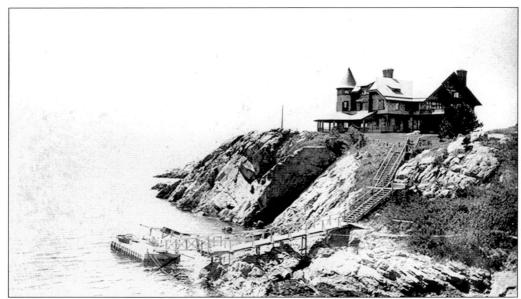

Braecleugh was completed in 1883 for Charles Wharton of Philadelphia, brother of Joseph Wharton, whose house, Horsehead, was completed a year later. Braecleugh, possibly the first of Charles Bevins's commissions in Jamestown, was a picturesque composition of gables, dormers, tower, and porches located on a promontory with a superb view out to sea. The property was condemned in 1905 for the creation of Fort Wetherill. (Jamestown Historical Society Collection.)

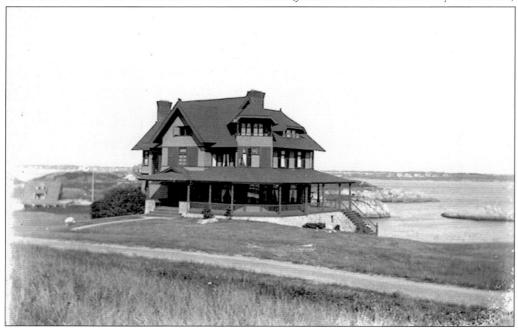

Benjamin Shoemaker of Philadelphia was the builder in 1883 of Stornaway, another early Bevins design. Shoemaker's daughter married J.S.L. Wharton, the son of neighbor Charles Wharton. Stornaway also was lost to the 1905 construction of Fort Wetherill. (Jamestown Historical Society Collection.)

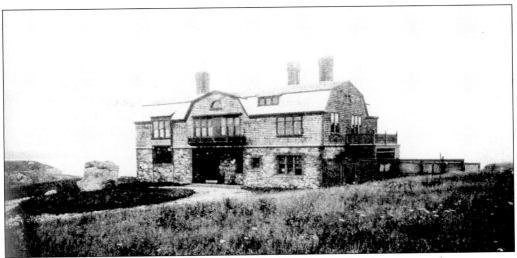

William Trost Richards, a well-known marine painter, felt that Newport was becoming too crowded and too grand, and decided to move to Jamestown. In order to jumpstart the development of the Dumplings, he is believed to have been given choice land on the cliffs of the future Fort Wetherill. In 1881, he built a gambrel-roofed house of his own design, and he did attract other Philadelphians to the area. (Newport Historical Society Collection.)

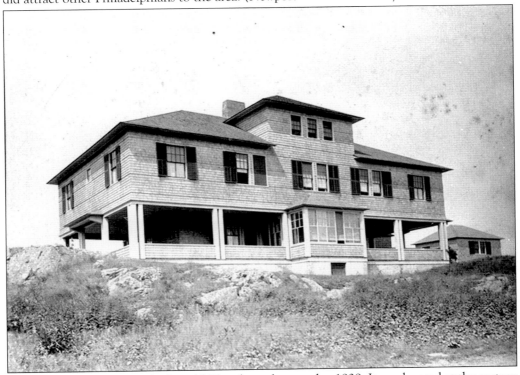

The Crawford cottage was built in 1895 and was destroyed c. 1939. It was located at the eastern end of Highland Drive. The house exemplifies the trend toward the end of the century of abandoning the irregularity of the early Shingle style and moving toward symmetry. (Jamestown Historical Society Collection.)

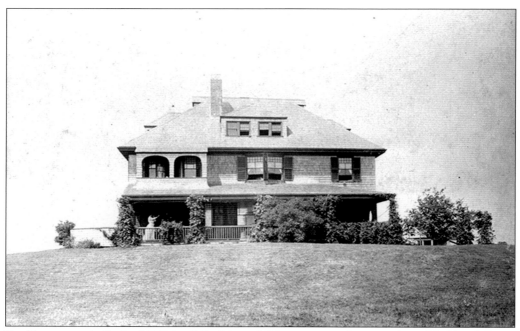

Rockburn was built in 1889 by F.B. Rice of Worcester, and it stood on Highland Drive overlooking land that would later be condemned for Fort Wetherill. (Jamestown Historical Society Collection.)

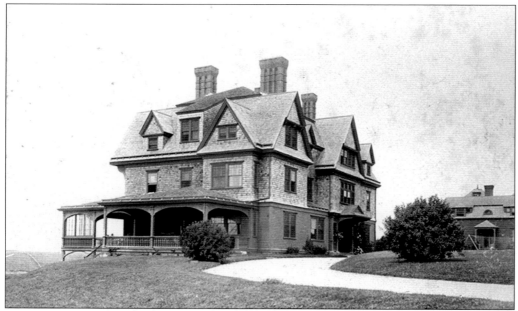

Highland was built in 1886 for Wistar Morris, a director of the Pennsylvania Railroad. It is distinguished by its cross gables and four tall chimneys. In 1888, the house was described as "one of the most attractive on the island, being second in cost to Joseph Wharton's only" and having an interior "elaborately finished in different hardwoods." The design is attributed to Stanford White of McKim, Mead, and White. (Jamestown Historical Society Collection.)

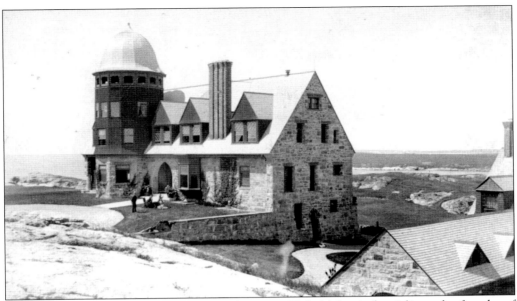

Horsehead was built in 1882 for Joseph Wharton, a Philadelphia industrialist and a founder of Bethlehem Steel. Wharton is seen here standing on his front lawn with members of his family. The house was the first on the present Highland Drive and occupied a 30-acre site. Its size, stone-and-shingle exterior, and massive tower give the house a commanding presence. (Wright Collection.)

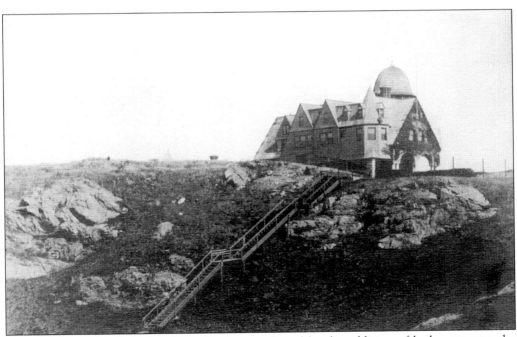

Horsehead, as seen from the shore, has been enlarged by the addition of bedrooms over the porch. This renovation, incorporating paired gables typical of the Shingle style, was done in the late 1880s by the original architect, Charles Bevins. J.D. Johnston was the contractor for the house and the architect as well for the carriage house. (Wright Collection.)

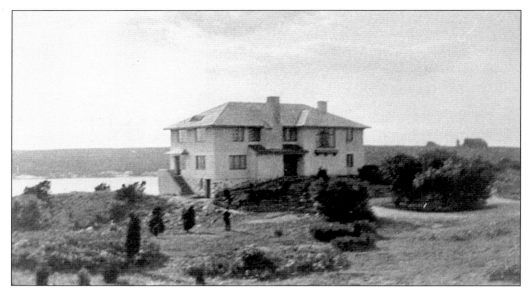

Sited at the edge of Cedar Point, this house was built for Dr. John Marshall of Philadelphia. Designed by DeArmond, Ashmeade, and Bickley and built in 1916, its stuccoed exterior reflects the growing trend away from the Shingle style. The original landscape, shown shortly after construction, was far more open than at present. Extensive gardens to the right of the house were established by Dr. Marshall's daughter, Mrs. Hiram Eliason. (Jamestown Historical Society Collection.)

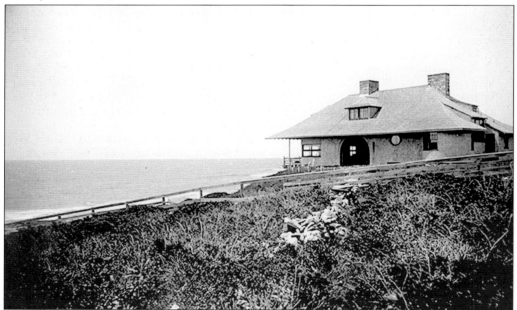

Grey Ledge was built for Eliza Alexander in 1895 and was the first summer cottage on Beavertail. Designed by Philadelphia architect Wilson Eyre, it featured a driveway that passed through the middle of the house. A fireplace within this passageway suggests the space was to be used as a terrace, protected from the wind. In 1908, Mrs. Alexander's sister opened a teahouse at the site. The building burned down in 1942. (Jamestown Historical Society Collection.)

Six

THE WATERFRONT
AND ITS ACTIVITIES

Jamestown's summer visitors came to get away from the cities and to enjoy life at the seaside. Swimming was thought to be a healthful activity as well as recreation. Land developments aimed at summer visitors typically included a beach and pier for bathing. Even Shoreby Hill, more suburban than the other developments, had a pier and bathhouses. The town beach at Mackerel Cove had a substantial pavilion, no doubt considered a useful investment to attract visitors. Watersports were popular, evident in the many contests at an annual event held at the Conanicut Yacht Club.

Boats were an integral part of summers in Jamestown. The comings and goings of the ferries provided a rhythm to the waterfront. There was a boat livery service at East Ferry where one could rent a boat for the time required. The affluent had their own launches for transportation as well as pleasure. Families often had several boats for different purposes. The wealthy, as a matter of course, had their yachts. Yacht owners, however, were not obliged to take command, as paid captains and crew were the norm. Jamestown was particularly suited for small boats, given its coves for anchorages, its protected waters, and the lack of a heavily commercialized waterfront. While boating today is often associated with recreational fishing, in the early 20th century, fishing for sport seems to have been done from the shore, which is why Beavertail has long drawn visitors to the island. Robert Goelet was one of Newport's wealthier summer residents, but he came to Jamestown to fish. He and two friends built a private fishing club on Beavertail's eastern shore, an area long popular for the fishing camps of local and summer residents.

For many of Jamestown's visitors, it was no one activity that was the attraction but the range of pastimes that were available. Anna Wharton Morris, in *A Trip Across the Bay*, describes a day with guests at Horsehead:

> All guests were given free use of the resources of the house, rocks and harbor,—and were expected to do exactly as they liked. Some sat inside playing the piano, some sat outside playing the guitar or banjo; some sat in rocking chairs, some on the grass; while some went on a climbing tour, proudly led by father carrying his big stick. Some played tennis or quoits, some rowed; and a fine party of young folks went swimming off our pier, diving or jumping from its rail. And whatever we did, we sang in doing it.

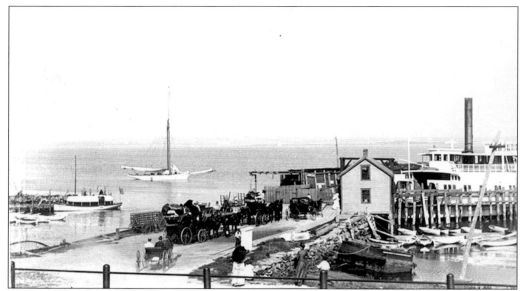

The East Ferry wharf in 1890 had no buildings other than those serving the ferry. Abbott Chandler's boat livery is on the south side. (Jamestown Historical Society Collection.)

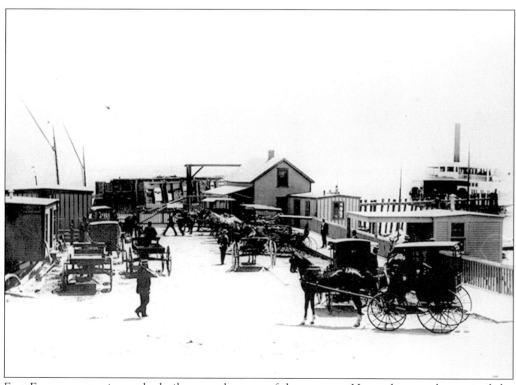

East Ferry was starting to be built up at the turn of the century. Horse-drawn cabs awaited the arrival of the *Conanicut*. (Jamestown Historical Society Collection.)

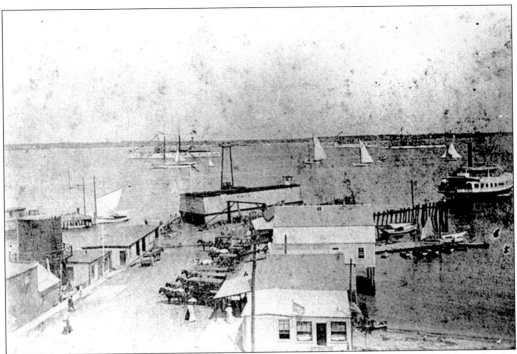

By 1910, East Ferry had been built up on its north and south sides. At the end of the wharf is a coal shed, on which was mounted in 1898 one of the *Jamestown*'s pilot houses to direct ferry captains into the slip after dark. Since the boilers of the ferries were coal-fired, significant amounts of coal were needed nearby. (Jamestown Historical Society Collection.)

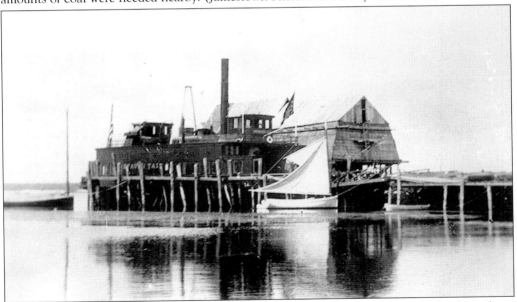

In this photograph of the West Ferry, the *Beaver Tail* is at the dock. Adjoining the ferry slip is the storage shed for the coal business that was operated before 1912 by John A. Saunders. (Jamestown Historical Society Collection.)

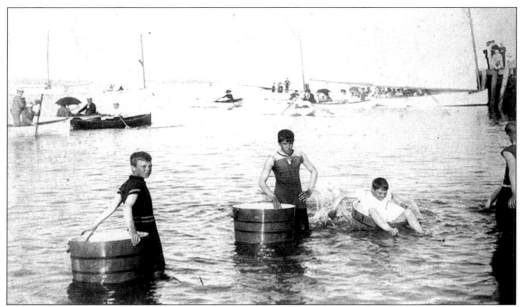

Watersports competitions were popular and were held at the town dock and the Conanicut Yacht Club. (Jamestown Historical Society Collection.)

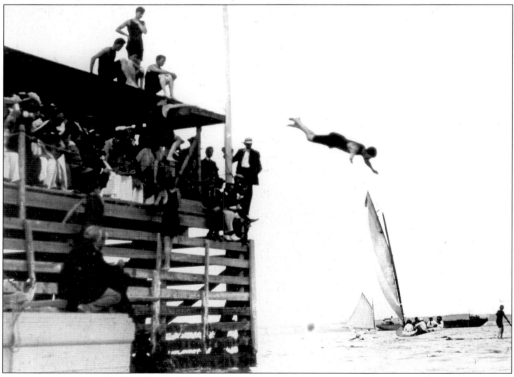

At the Conanicut Yacht Club, Watersports was a daylong event starting *c.* 1914 and open to all island residents. Activities included swimming, diving, jousting, and rowing and sailing races. The roof over the end of the pier was one of the diving platforms. (Dodge Collection.)

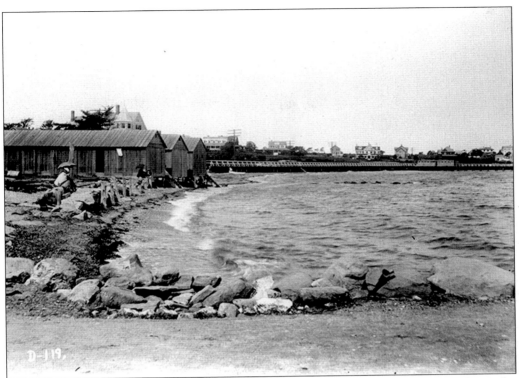

These bathhouses were for the guests of the Bay View Hotel. In the background are the boardwalk and the Shoreby Hill bathhouses. To be seen walking to the beach in one's bathing costume was considered unsuitable. (Jamestown Historical Society Collection.)

James Mapes Dodge and his wife, Josephine Kern Dodge, are shown on the Shoreby Hill pier in animated conversation. The pier was built in 1899 as an amenity to attract buyers to Shoreby Hill property. (Dodge Collection.)

These ladies on the stone jetty at East Ferry, with the Shoreby Hill boardwalk in the background, are properly dressed in spite of the informality of the occasion. Hats have been removed, perhaps just for the photographer. (Jamestown Historical Society Collection.)

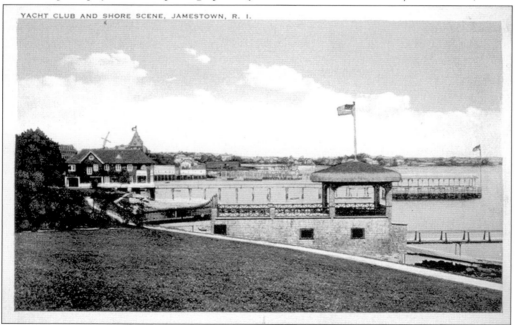

YACHT CLUB AND SHORE SCENE, JAMESTOWN, R. I.

This postcard view of the Cliff Walk shows the John Price Wetherill dock and boathouse, with the Conanicut Yacht Club and its pier behind. (Jamestown Historical Society Collection.)

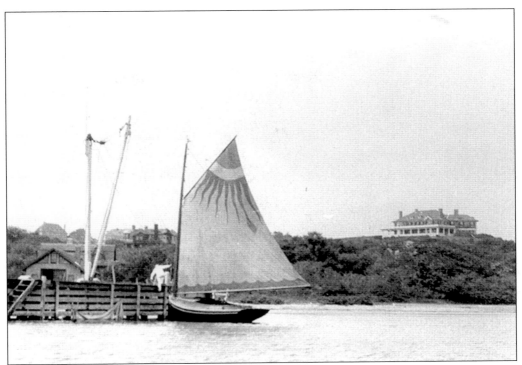

The catboat *Arusa* was at the Dumplings dock c. 1910. It belonged to F.D. Wetherill, who painted the sunburst on its sail. Altamira, the Henszey house, is in the distance. (Jamestown Historical Society Collection.)

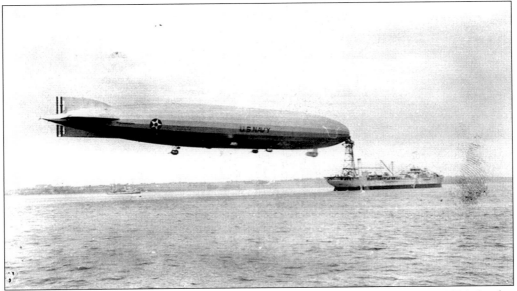

The dirigible *Shenandoah* was built for fleet reconnaissance, entering service in 1924. In this view it is moored to the oiler *Patoka*, which has been converted for this purpose by the addition of a mast. The first rigid airship constructed by the navy, the *Shenandoah* was destroyed in a thunderstorm in 1925. (Jamestown Historical Society Collection.)

Launched in 1920, *Skipper* was a 26-foot runabout owned by Charles W. Wharton. He designed and built the boat at the family shipyard in Jamestown. (Dodge Collection.)

Thelma, J.S.L. Wharton's yacht, was built in 1890 as a cutter of the Forty-six-Foot racing class (measured 46 feet at the waterline; 62 feet overall). It was converted to a schooner in 1897. The designer was Burgess, and the builder was Lawley. (J.S.L. Wharton III Collection.)

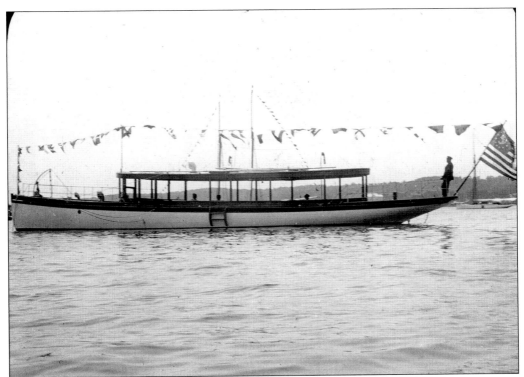

Fayelle, built at Philadelphia's Essington Shipyard, was the second motor launch with this name belonging to James Mapes Dodge. The name *Fayelle* derived from interest the family had in Faial, an island in the Azores. *Fayelle* was given to the military for service during World War II. (Dodge Collection.)

This view up the bay from Clingstone shows Charles W. Wharton's yawl, *Carina*, in the foreground and navy warships in the distance. (Dodge Collection.)

A stiff breeze in the waters off the Dumplings made an exciting race for these model sailboats in the 1890s. Above them on the shore is Charles Wharton's Braecleugh. To the right is Fort Dumpling. (Jamestown Historical Society Collection.)

Model sailboats were still being raced in the 20th century. A trophy was presented to the winner of the Clingstone Model Yacht Club's Open Race of July 7, 1923. From left to right are J.C. Jones, Charles W. Wharton, "Commodore" Amelia Bird Shoemaker Wharton, Joseph S.L. Wharton Jr., and Brinton S. Wharton. (J.S.L. Wharton III Collection.)

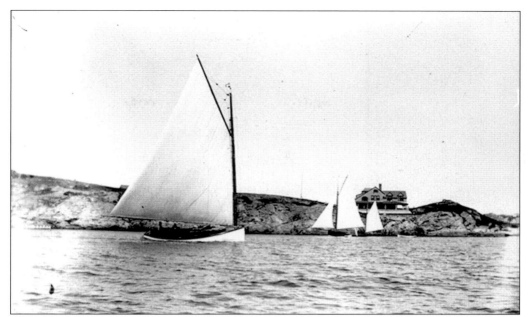

The Annette Tilden cottage, the Steamboat, later destroyed for Fort Wetherill, looked south to the sea. Sailing close to shore is J.S.L. Wharton's gaff-rigged yawl, *Sea Bird*. Farther out is a roomy catboat that may have been a pleasure boat or a workboat. (Jamestown Historical Society Collection.)

Corra Bahn was the launch of Theophilus and Anna Stork. It came to Shoreholme to take the Whitalls for an outing to Fowlers Rocks, the Storks' summer cottage several miles farther north on the east shore. (Jamestown Historical Society Collection.)

John M. Whitall had a number of pleasure boats. The *Columbia*, a handsome gaff-rigged schooner is thought to be the largest, at 58 feet. (Jamestown Historical Society Collection.)

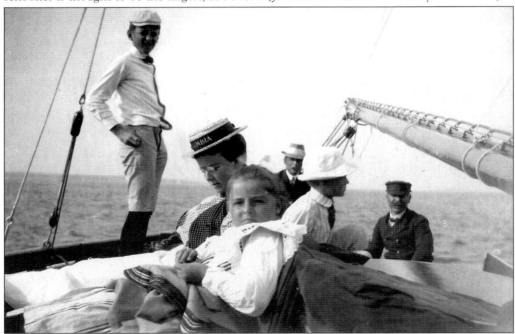

Columbia is out for a sail, with John Whitall at the helm and Mr. Ross, the boatman, at the ready. One of the ladies is sporting a straw boater with a *Columbia* hatband. (Jamestown Historical Society Collection.)

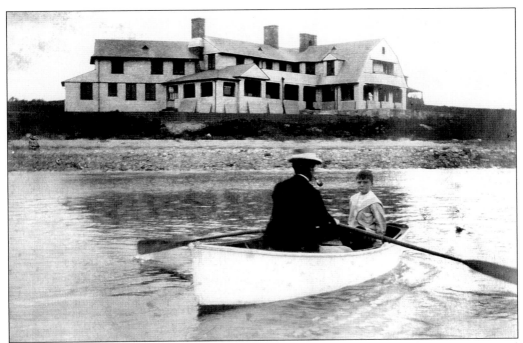

John Whitall rows with his son Billy in front of Shoreholme. (Jamestown Historical Society Collection.)

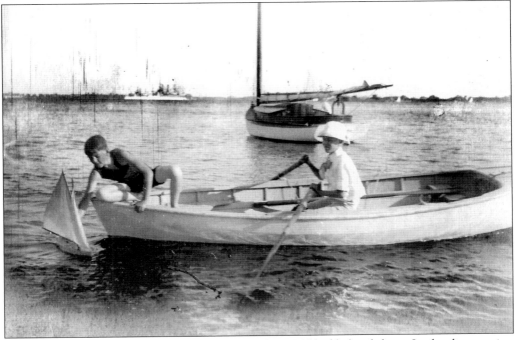

The Whitall boys sail a model boat, with the catboat *Mildred* behind them. In the distance is a backdrop of warships, a common sight in the summer when the fleet was in. (Jamestown Historical Society Collection.)

These competitive youngsters are preparing to race buckboards the length of the Whitalls' pier. (Jamestown Historical Society Collection.)

The Whitalls' motor launch *Baloo* is shown coming in for a landing. (Jamestown Historical Society Collection.)

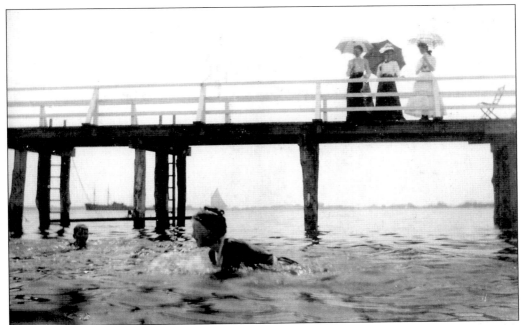

Bathing could be a spectator sport as ladies watched the children from the Whitall pier. Parasols protected the women from getting a suntan, considered unfashionable at the time. (Jamestown Historical Society Collection.)

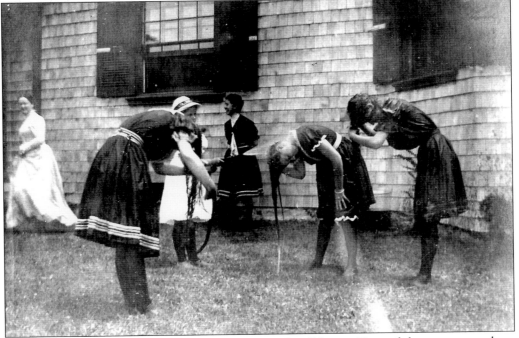

After swimming, girls rinsed out their hair at the Whitall house. Turn-of-the-century modesty required that bathing costumes cover all but a girl's head and arms. (Jamestown Historical Society Collection.)

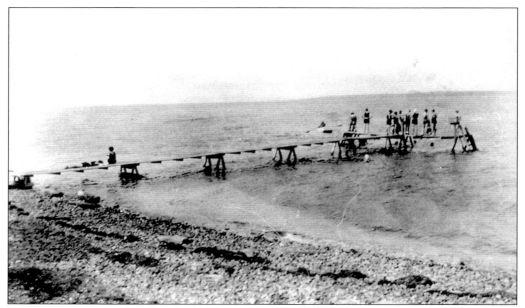

Campers at the Providence YWCA's Camp Seaside enjoyed swimming off its pier, just south of the Conanicut Park steamboat landing. Standards of modesty in 1929 had become more relaxed than those of the prior generation. (Jamestown Historical Society Collection.)

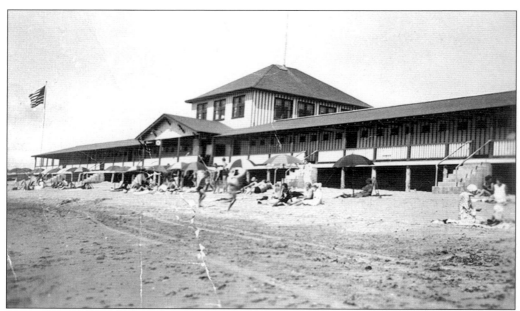

In 1928, the town built a pavilion at Mackerel Cove, the municipal beach. There were 100 bathhouses and a second-floor dance hall. Originally, the building was on the other side of the road, but the mistake was soon realized. Within the year, the structure was moved onto the beach. Note the concrete steps, the only part of the pavilion that survived the 1938 hurricane. (Jamestown Historical Society Collection.)

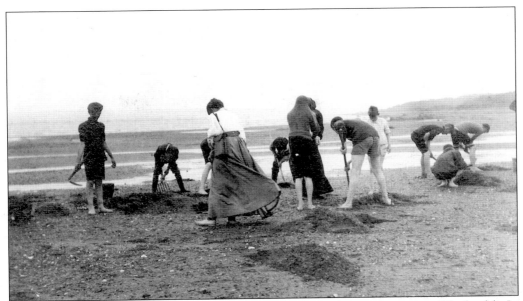

Residents at Maplewood enjoyed many outdoor activities both for recreation and for health. In this photograph, they are looking for clams north of the creek. (Barbara Magruder Collection.)

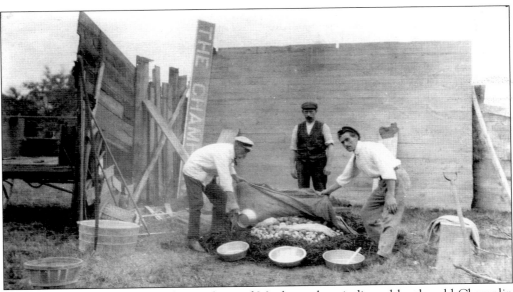

A clambake was prepared for the residents of Maplewood, as indicated by the old Champlin sign. (Barbara Magruder Collection.)

The massive gateposts of the service drive at Horsehead, Joseph Wharton's estate, tested the athletic ability of his daughter Anna Wharton and her friends in September 1893. Anna Wharton is on top of the right-hand post. (Templeton-Cotill Collection.)

A gathering at Horsehead in August 1886 includes, from left to right, the following: (seated on ground) Mrs. Joseph S. Lovering Jr., Joanna Wharton Lippincott, Mary Wharton, Mrs. Joseph Wharton, and Lily Rhoads; (on rock) Anna Wharton, Gilpin Lovering, Corbit Lovering, and Molly Stewardson. (Wright Collection.)

Catharine Morris participated in dance as well as other artistic pursuits. She is at Horsehead in 1918 dressed as an Egyptian dancer before a fete at the Newport Art Museum to raise money for servicemen. The granddaughter of Joseph Wharton, she was later Catharine Morris Wright, known for her painting, writing, and philanthropy. (Wright Collection.)

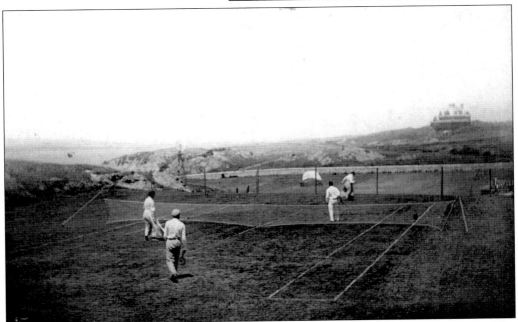

The tennis court at Horsehead was built before country clubs started in Jamestown. The Whartons' "tennis club" is a group of friends who played on each other's courts. The Wistar Morris House is in the background. (Wright Collection.)

Mildred Whitall rides sidesaddle on her horse Silverlocks at Shoreholme. The costume looks better suited to posing than to riding. (Jamestown Historical Society Collection.)

Theatricals were popular with all ages. Here, the young Whitalls are performing their own version of *Red Ridinghood*. (Jamestown Historical Society Collection.)

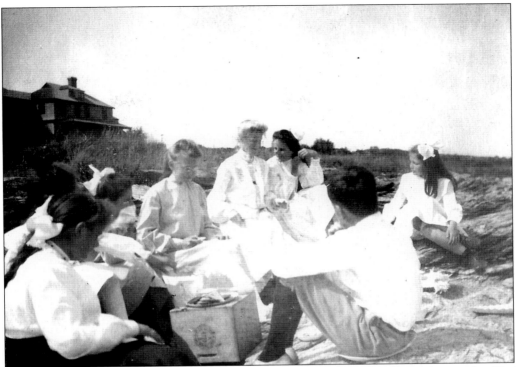

Picnicking was a favorite summer activity, here enjoyed by the Whitalls on their rocks. The author can attest that this was a great spot for a picnic. The Hacker House is seen in the background. (Jamestown Historical Society Collection.)

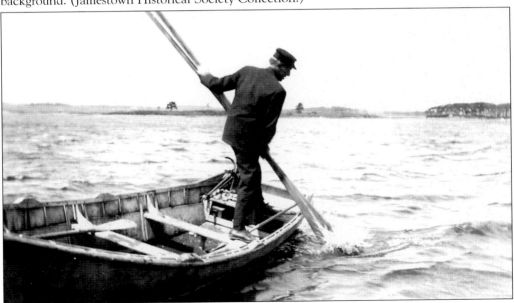

Martin Dykstra is shown tonging for shellfish. Although he made his living as a boatman, it is noted Dykstra stood on the seat of his rowboat, a practice that is generally frowned on by boaters. (Jamestown Historical Society Collection.)

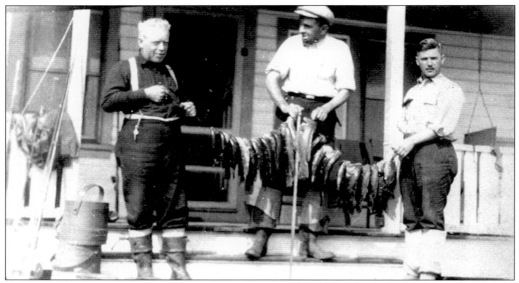

Three fishermen at the Beavertail camp of the Watson, Gardner, and Carr families have a successful day. From left to right, they are Andrew Goodman, Henry Livingston, and John Brooks. (Jamestown Historical Society Collection.)

This former streetcar had been used as a workshop for the construction of the Movable Chapel. In 1899, it was bought as a movable fishing camp by D.C. Watson, A.R. Cory, Fred Anthony, and Wager Briggs. They outfitted it with six bunks and a small kitchen at one end. Its first trip was to Beavertail. (Jamestown Historical Society Collection.)

Seven

THE 1938 HURRICANE

The most severe hurricane in the history of New England struck on September 21, 1938. A contemporary account was given by Capt. Cary W. Magruder (later commodore) in a letter to his friend and Shoreby Hill neighbor Cmdr. Frank Slingluff, in Washington at the time. Following are excerpts from that letter of September 27.

Everyone expected the storm to pass well clear of Nantucket and that we would have our usual rather heavy but not serious northeaster. Instead of following the predicted route, the storm moved directly north at increased rate of speed. The wind remained unchanged in direction and increased in velocity, so that between 5 and 6 it was probably blowing a hundred knots. The *Beaver Tail* was secured at the east Jamestown landing. She started getting up steam about 2 o'clock. The *Governor Carr* came into the Jamestown slip for the 3 o'clock trip and secured. Between 4 and 6 it was evident that the slip was beginning to give way and both boats were in imminent danger of being wrecked. The *Beaver Tail* left first in the height of the gale. She got about half way across the Bay to Gould Island and could not make any further headway. She ended up aground on the eastern shore of Jamestown, up near the Thompsons' place, that is about 4 or 5 miles up north. She sits on a jagged rock, with her bottom badly pierced, her engines and boilers out of line. The *Governor Carr* cleared the slip and had proceeded only a few hundred yards when her propeller became fouled, either by some of her lines or some wreckage. In any case, the machinery went dead. She ended up exactly in front of Webster Wetherill's place, listed about 45 degrees, with her keel sitting on Webster Wetherill's seawall. The water was some 10 feet above high tide. A personal item in connection with her momentous voyage may interest you. Cam Smith and his family plus automobile were among those who made the trip from the ferry slip to Wetherill landing. The passengers and cars had gone on board at 3 p.m., and as the water came up the apron of the ferry slip was washed away, so that it was impossible to take off the passengers before she sailed.

Along the waterfront on the east shore, the water was about 3 feet above the roadway. A half dozen cars were stalled and were rolled through the park of lower Shoreby for perhaps a hundred yards. Richardson's Garage and the White Nook were completely washed away, the debris ending up on Mrs. Bowen's porch. The Country Club buildings suffered about $2,500 worth of damage. The 11th and 13th holes will require a new layout. The Yacht Club building was not seriously damaged. The pier is gone. One or two small sailboats that were still there were lost. There is no shortage of food or danger of disease. We have no electricity for lights or refrigerator, but it is promised for the end of this week. The damage to your place was in accordance with my wire of last night, and as far as your property is concerned there is little reason for you to come to Newport.

Sincerely, C.W. Magruder.

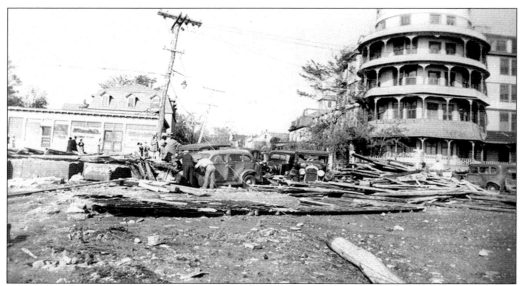

The destruction at East Ferry was evident in the debris, the storm-tossed cars, and the leaning telephone poles. Some of the debris may have come from the wreckage of the Horgan Block buildings that had not yet been torn down. (Jamestown Historical Society Collection.)

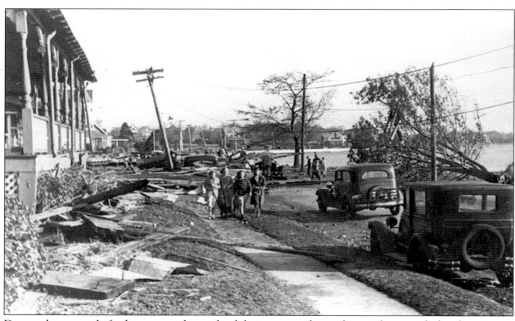

Downed trees, shifted cars, and much debris attested to the violence of the hurricane. (Jamestown Historical Society Collection.)

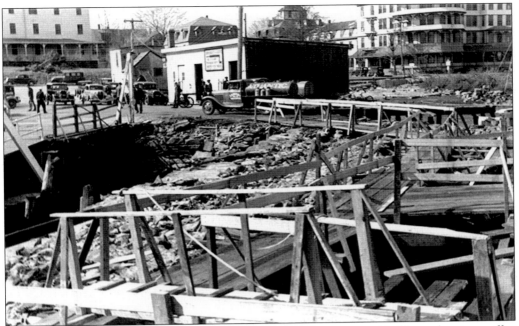

During the reconstruction of the East Ferry wharf, catwalks were provided for pedestrian traffic. (Jamestown Historical Society Collection.)

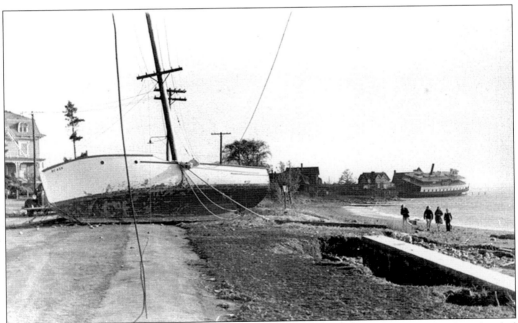

Arthur Clarke's boat, *Nellie*, came to rest on Conanicus Avenue. The *Governor Carr* landed on the Wetherill lawn, and electric wires were as yet unrepaired. (Jamestown Historical Society Collection.)

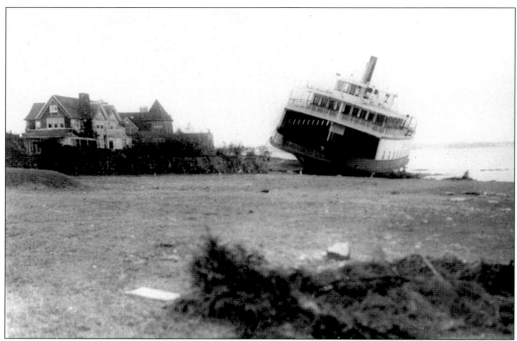

A dramatic casualty of the hurricane was the *Governor Carr*, which got its propeller fouled as it was trying to get to a safe harbor in Newport. It made this trip with a few unhappy passengers aboard. Its resting place for two months was Webster Wetherill's lawn. (Jamestown Historical Society Collection.)

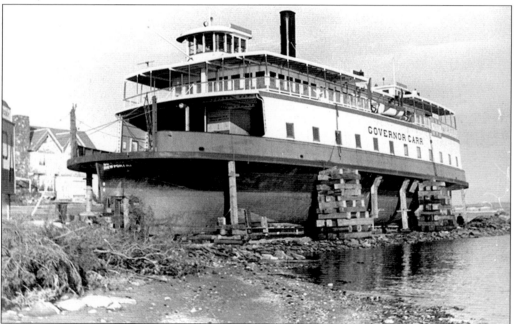

The *Governor Carr* was righted using chocks and block and tackle. (Jamestown Historical Society Collection.)

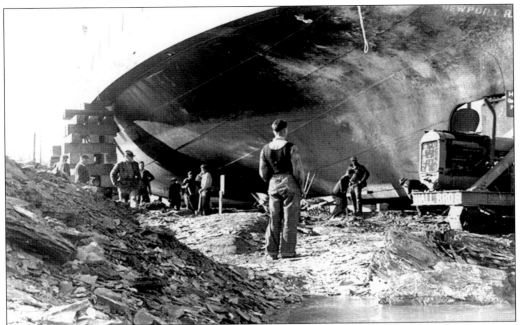

The *Governor Carr* was supported by blocks while men and equipment dug out a channel to refloat it. (Jamestown Historical Society Collection.)

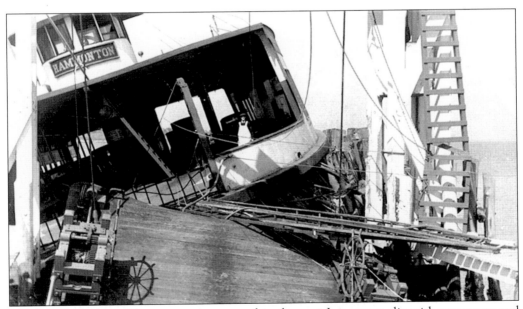

"In the west bay, the *Hammonton* was secured in the west Jamestown slip with passengers and automobiles on board. Between 4 and 10 p.m. she was out of communication with the town because of water over the approaches to the slip. As the tide receded, one overhang of the ferry hung up on some pile, and she was given a rather bad list. The passengers were taken off about 10:30. The next day she was cleared." —C.W. Magruder, September 27, 1938. (Jamestown Historical Society Collection.)

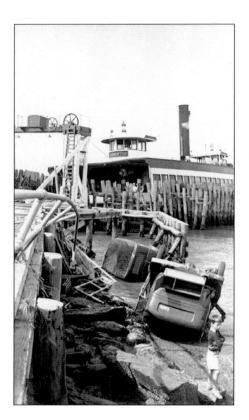

As shown in this photograph, cars were washed off the West Ferry wharf. (Jamestown Historical Society Collection.)

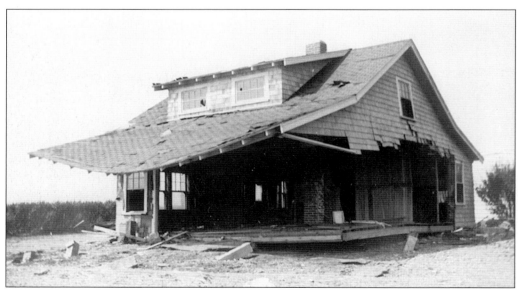

Out near the Beavertail Lighthouse, Arthur Clarke's fishing camp lost its porch and most of the first floor. (Jamestown Historical Society Collection.)

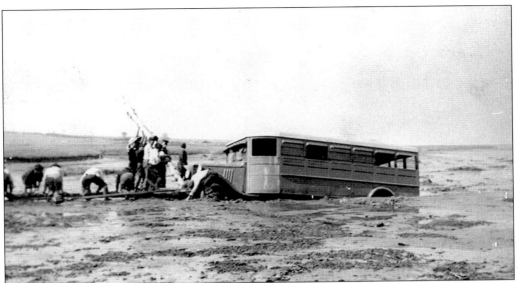

"The saddest catastrophe happened when Norman Caswell tried to get the school bus, with children, across the causeway at the swimming beach. The water was over the roadway, of course he thought he could make it. The bus went dead. Some of the children got out. Norman and one child survived. Five [in fact, seven] children were drowned. Of these children, four belonged to one family." —C.W. Magruder, September 27, 1938. (Jamestown Historical Society Collection.)

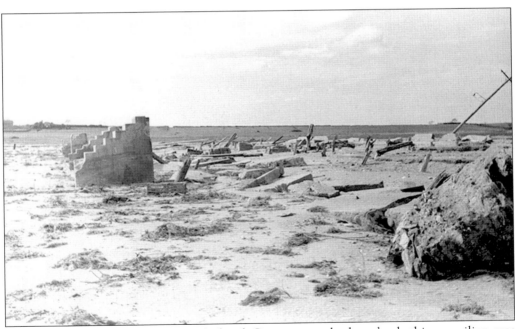

The force of the sea passing up Mackerel Cove was such that the bathing pavilion was completely washed away except for the concrete steps. Never again would a structure of any size be built in that location. (Jamestown Historical Society Collection.)

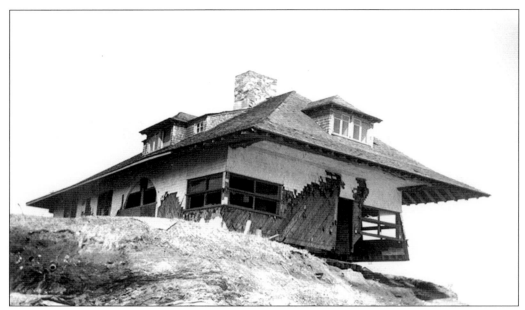

The porch of Grey Ledge on Beavertail was destroyed and much of the shingling blown away. Although the house seemed to be in a precarious position, it was repaired. It burned down in 1942, just before it was to be turned into a recreation center for Fort Burnside. (Jamestown Historical Society Collection.)

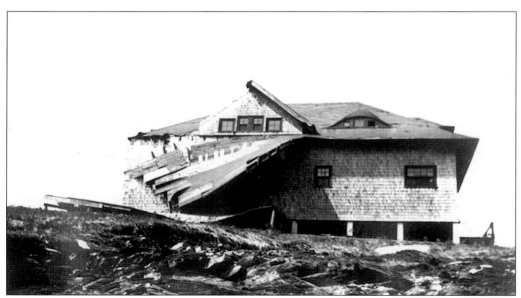

The Ambrose Kennedy cottage was originally the barn of Grey Ledge. It had been moved closer to the water from its original site. Most of the damage was to its porch and roof. (Jamestown Historical Society Collection.)

Eight

LIGHTHOUSES AND THE MILITARY PRESENCE

Beavertail has had some sort of structure aiding navigation since the very early 1700s. The first actual lighthouse was erected in 1749 by Peter Harrison, architect of the Redwood Library, and it consisted of a 58-foot wooden tower. That lighthouse was the third erected along the Colonial coast. However, it burned down after four years and was replaced by a taller fieldstone tower. That tower served until the construction of the present lighthouse in 1856. The existing tower is 52 feet high and constructed of granite blocks 8 and 10 feet long. Adjoining is the keeper's house, of stuccoed brick with a hip roof. A similar building is next to it, but this, the assistant lightkeeper's house, is somewhat smaller and was not built until 1898. Other buildings were once on the site primarily for the purpose of sounding the horn or whistle used in fog. Before electricity, this could involve producing steam with the requisite boilers and storage for coal or oil. Over the years, various technologies for the whistle and lantern were tried out at Beavertail, but in the end, technology has made most of the facility obsolete. The lighthouse was automated in 1972, but its history survives in the assistant keeper's house, which has been turned into a museum.

The waters at the north end of the island were less treacherous than those at Beavertail, and until the mid-19th century, they saw less traffic. After the establishment of steamboat routes out of Wickford, there was enough traffic to warrant a light at Conanicut Point. First the Wickford Railway and Steamship Company maintained a private light there. Then, in 1886, the U.S. Lighthouse Service built Conanicut Light as an official aid to navigation. This charming Gothic structure served until 1933. Like many others, Conanicut Light has become a residence.

There has been a long history of military involvement in Jamestown. The most substantial installations were Fort Wetherill and Fort Getty, built at the beginning of the 20th century, and those at Beavertail constructed during World War II. Forts Wetherill and Getty were part of a coastal defense system that was authorized in 1890, when Spain was considered a threat, but was not built until the early 1900s. Fort Wetherill's artillery in World War I included 12-inch disappearing guns that could be lowered out of sight in subsurface emplacements. During World War II, antisubmarine nets were strung across the East Passage from Fort Wetherill and across the West Passage from Fort Getty. Located at each of the forts were POW camps where selected German prisoners were introduced to democratic principles before returning to assume government positions in Germany. Fort Burnside, on Beavertail, was established for artillery in 1942. One of the facilities at Fort Burnside was the Harbor Entrance Command Post, charged with the responsibility of identifying all ships approaching the bay. All of Jamestown's forts have been deactivated and turned into parks.

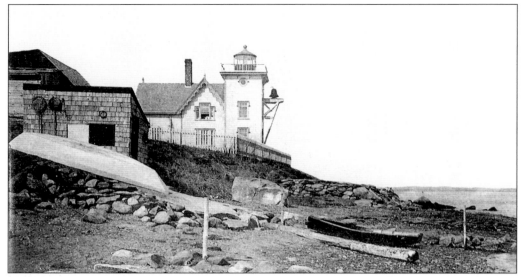

The Conanicut Lighthouse, built in 1886 and sometimes referred to as North Light, is not unique. Several other lighthouses on the East Coast had their keepers' houses built to the same simple plan: cross-gabled buildings with identical drip moldings over the windows and intricately cut bargeboards decorating the eaves. The towers, however, seem always to have differed from each other, probably to make for easy identification from the water. (Jamestown Historical Society Collection.)

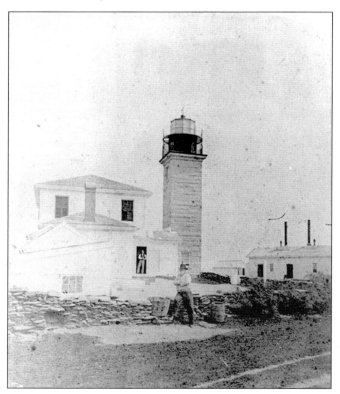

This view of Beavertail Light from the west predates the addition of the assistant keeper's house in 1898. That structure would be built on the site of the sheds in the foreground. To the right is the whistle house. Whistle technology changed over the years, using either compressed air or steam before electricity was available. (Jamestown Historical Society Collection.)

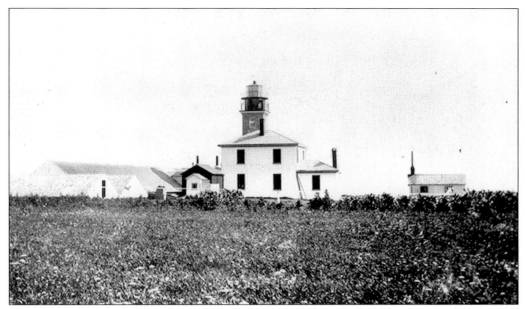

Vacationers who had come down from Conanicut Park took this photograph of Beavertail Light *c.* 1896. The two short stacks just to the left of the tower are on the steam whistle house. One of the large sheds to the left is thought to cover a cistern and collect water for the steam whistle boilers. The building to the right of the tower may be an abandoned whistle house. (Jamestown Historical Society Collection.)

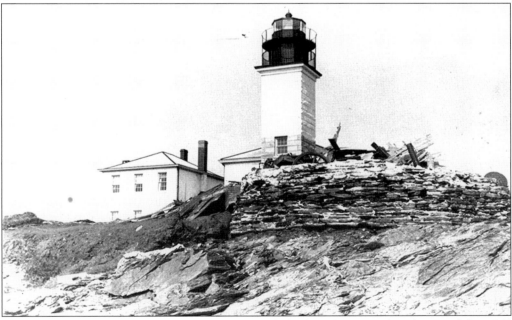

Wave action during the 1938 hurricane uncovered the long-forgotten foundation of the 1755 lighthouse and destroyed the whistle house that stood on it. That foundation had supported a massive fieldstone tower of 64 feet, 12 feet taller than the present tower. (Jamestown Historical Society Collection.)

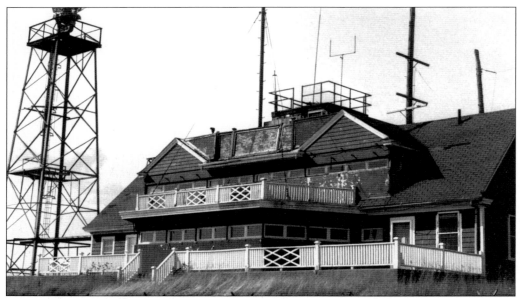

The Harbor Entrance Control Post was built in 1943 to observe and identify ships entering the bay. While identification relied on visual inspection initially, detectors became increasingly sophisticated with underwater magnetic loops and sound detection. The facility was disguised as a Shingle-style summer house, but it may be the only such house that has the shingles laid over reinforced concrete. (Photograph by Walter Schroder.)

The code name for the naval radar station at Beavertail was Mickey. The second largest naval radar station in the world during World War II, the facility developed airborne radar intercept equipment with the Massachusetts Institute of Technology. Mickey also guided navy pilots to enemy targets and was used for the training of pilots and controllers. (Jamestown Historical Society Collection.)

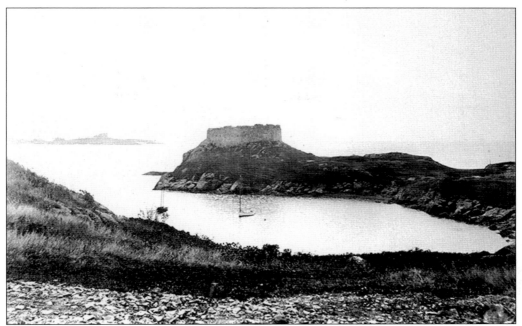

Fort Dumpling, built in 1800 for protection against the French, was an elliptical fieldstone fort of a type known as a Martello tower. Four gun emplacements were planned, but there is no record that they were ever installed or that the fort was ever manned. In 1898, Fort Dumpling was demolished to make way for Fort Wetherill. (Jamestown Historical Society Collection.)

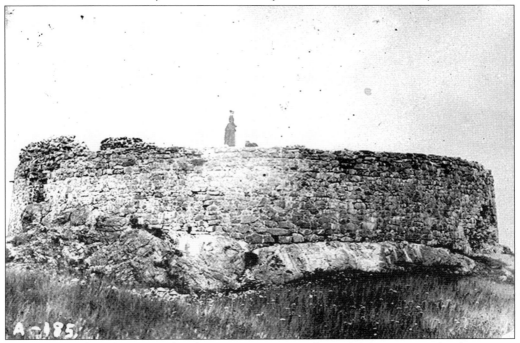

As Fort Dumpling deteriorated, it became an increasingly romantic ruin, popular for picnics and outings. (Jamestown Historical Society Collection.)

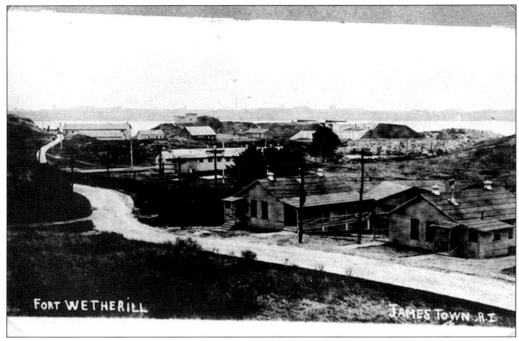

Fort Wetherill was built from 1902 to 1907 and included seven batteries. This postcard is from the World War I era, showing a fully developed site. The fort was reactivated and new troop facilities added in World War II. (Jamestown Historical Society Collection.)

The USO Club was built in 1942 on the site of the Gardner House to serve the men stationed at Jamestown's forts. The club ceased operation in 1946, and the building has in subsequent years served as the town's recreation center, police station, and harbor management office. (Jamestown Historical Society Collection.)

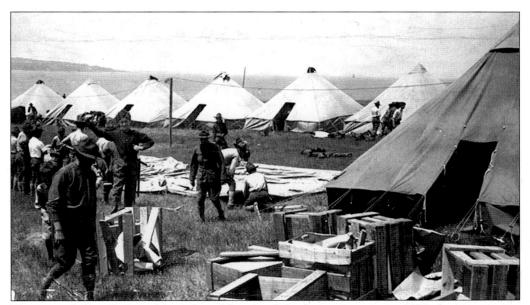

The site of Fort Getty was purchased by the federal government in 1900, but it was not garrisoned until 1909. The Rhode Island National Guard used Fort Getty extensively for training, as in this photograph from 1913. During World War II, ship traffic in the West Passage was controlled by a boom and antisubmarine net stretched across the bay between Fort Getty and Fort Kearney in Saunderstown. (Jamestown Historical Society Collection.)

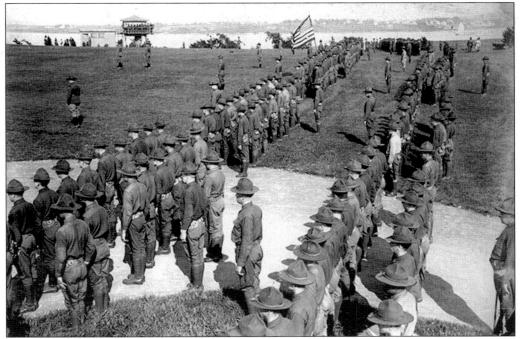

Fort Getty was the site of training for the Rhode Island National Guard between the world wars. During World War II, Fort Getty was used to introduce German prisoners of war to the virtues of democracy. Classes graduated every 60 days. (Jamestown Historical Society Collection.)

The Red Cross ambulance of 1944 was operated by, from left to right, Violet Drury, Dr. Charles B. Ceppi, Elizabeth Clarke, Dorothy Coste, Kathryn Hunt, Beatrice Chew, Betty M. Bartlett, Sarah Weeden, Lenore MacLeish, and Mary Wadleigh. The dachshund is waiting for Betty Bartlett. (Jamestown Historical Society Collection.)

The large number of naval officers who retired to Jamestown occasioned the tradition of the annual Admirals' Tea. Guests at the second tea on August 10, 1925, from left to right, are as follows: (front row) Rear Adms. W. Marshall '71, Y. Stirling '63, G. Remey '59, T. Jewell '65, and J. Jayne '82; (back row) Captain Todd and Rear Adms. R. Nicholson '73, B. Fiske '74, W. Swinburne '66, D. Coffman '76, A. Gleaves '77, and W. Bayley. (Jamestown Historical Society Collection.)